VITTORIO SERRA

All
VENICE

235 COLOUR PHOTOS AND MAP OF THE CITY

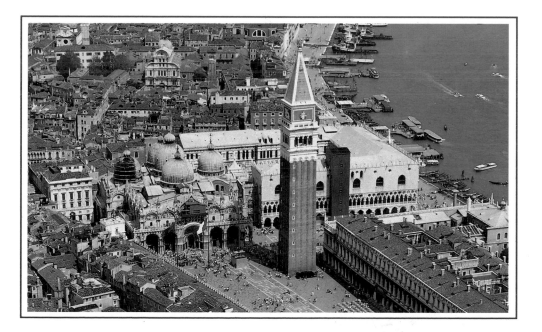

NEW EDITION

BONECHI EDIZIONI "IL TURISMO"

Exclusive distributor for Venice:

San Polo Souvenirs s.r.l.
Santa Croce, 360/G
30135 VENICE - ITALY
Tel. +39-041.275.89.73
Fax +39-041.275.04.09
E-mail: sanpolo-souvenirs@libero.it

Reprint 2009

© Copyright by CASA EDITRICE PERSEUS
© Copyright by Bonechi Edizioni "Il Turismo" S.r.l.

Print: Centro Stampa Editoriale Bonechi
Viale Ariosto 478/480 – Sesto Fiorentino (FI) - Italy
Tel. 055 576841 – Fax 055 5000766
e-mail: acarrani@bonechi.it

Photos: Bonechi Edizioni "Il Turismo" S.r.l. Archives
　　　　　Paolo Bacherini
　　　　　I-Buga S.a.s. - page 4 - 5 - 63 (Aut. SMA n. 000480 of 11.06.91); page 35 (Aut. SMA n. 00034 of 22.04.91);
　　　　　page 14 (Aut. SMA n. 710/877); page 2 - 45 (Aut. SMA n. 00034 of 22.04.91);
　　　　　page 119 (Aut. SMA n. 000480 of 11.06.91); page 126 (Aut. SMA n. 000480 of 11.06.91).

ISBN 978-88-7204-157-4

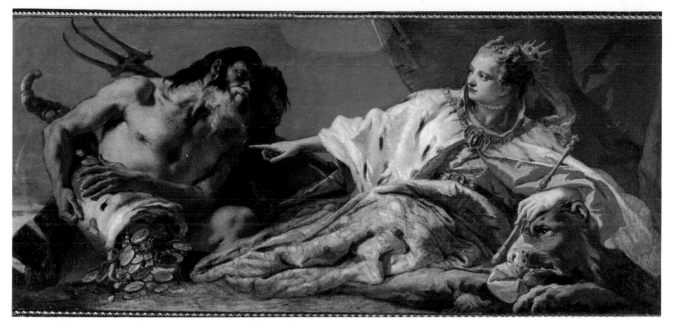

Neptune Offers Venice the Gifts of the Sea, by *G.P. Tiepolo* (Doges' Palacè); on the following two pages: *aerial views of St. Mark's Square.*

VENICE «QUEEN OF THE ADRIATIC»

First of all, why Venice? Let us go back to the time when non-Italic Indo-Europeans settled in the Venetian plains. They probably came from Illyria in the second millenium B.C. and over-ran the Euganean hills, founded Vicenza, Treviso, Padua, Este, Belluno and other centers. In the first century B.C., these towns were Romanized and it was at this point that the local population was given the name of Venetians. The word Venetians, if truly of Indo-European origin, could mean «noblemen»; if, on the other hand it is pre-Indo-European, its meaning would be «foreigners» or «newcomers». It is to be presumed, therefore that «newcomers» or «novi venti» led to Veneti (Venetians) and thence to Venezia (Venice).

Venice took many centuries to develop. The nucleus of the original settlement was in the area of today's Rialto district. A network of canals was planned and the earth the builders dug up, was used to strengthen the islands of the lagoon. The Grand Canal and the innumerable «rii» (lesser canals) of Venice, which by means of 400 bridges, link over 118 islets to each other today came into being over the centuries: tree-trunks were tightly bound together and used to consolidate the muddy little islands, creating the foundations of the houses and palaces. From East to West, the town measures 4,260 meters and from North to South it is 2,790 meters wide. It covers an area of 7,062 Sgkm. and its perimeter (including the islands of the «Stazione Marittima» (The Ferry Terminal), San Giorgio, Sant'Elena and Giudecca is 13,700 meters.

When Venice first appears, it looks like a dream-city, a gleaming splendid vision rising from the waters of the lagoon. Its delicate beauty changes with the seasons and unfolds countless treasures: historical places, natural beauties, art, the traditional hospitality and kindness of the people all make it a truly unique place. The famous Grand Canal or «Canalazzo», as it is called by the Venetians, with its marvellous succession of beautiful «palazzi» and picturesque houses is the main thoroughfare. Its inverted S winds for 3,800 meters through the town and its width ranges from 30 to 70 meters, and it is roughly 5 meters deep. It flows from North-West to South-East (dividing Venice in two) into the much wider St. Mark's Canal, which reflects the sparkling bulk of the Ducal Palace. The Grand Canal, crossed by three bridges (the Railway bridge, the Rialto and the Academy bridges), together with the 45 «rii» (little canals) that flow into it, link all the «sestieri» (districts) of the town to each other. The typical «rii» or «rielli» are mostly about 4 or 5 meters wide and can only be used by gondolas. The «rii» are nearly always flanked by narrow, twisty pathways or alleys called «calli». The calli lead into little clearings or squares called «campi» – if fairly large, or «campielli» – if small. The «rii» can also lead into little dead-ends or courtyards, called «corti».

Venice is divided into six «sestieri»: San Marco, Castello, Cannaregio, Santa Croce, San Paolo and Dorsoduro (which includes the parish of St. Eufemia on the island of the Giudecca). About 100.000 people live in the «sestieri».

Venice is 4 kms away from the mainland and is linked to it by ferry-boats, a double railway bridge (3,601 meters long and built 1841-46 and by a road bridge, built in 1931-32, which is 4,070 meters long and 20 meters wide. The two bridges run parallel to each other for quite a way.

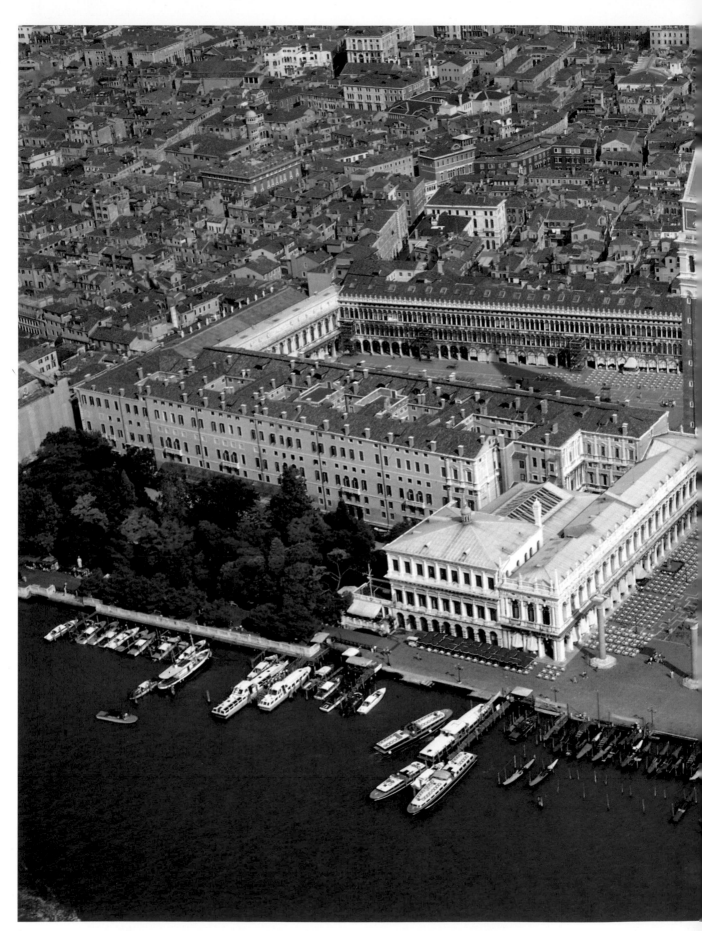

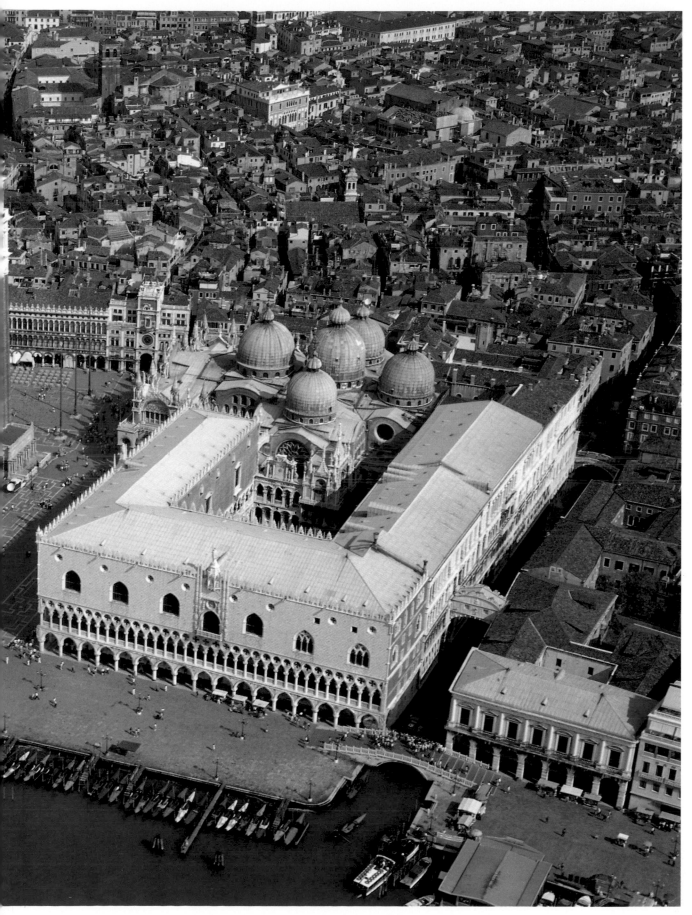

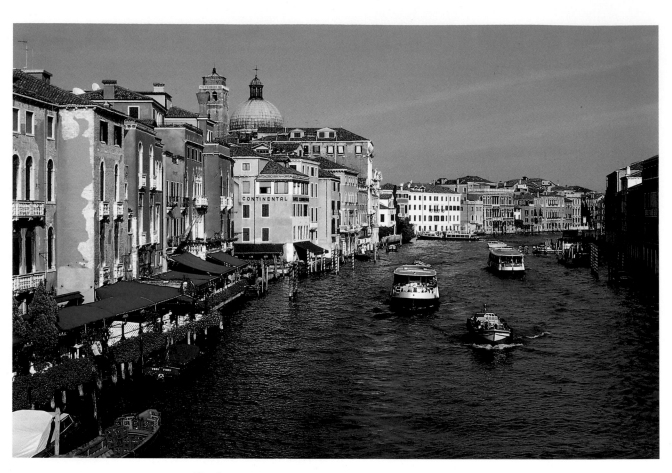

The Grand Canal; below, *the Santa Lucia Railroad Station.*

THE GRAND CANAL

The Grand Canal, shaped like a huge upside down «S» bisecting the city, is a little over 4 km ($2^1/_4$ miles) long, $4^1/_4$ meters (15 feet) deep, and from about 30 to 69 meters (100 to 225 feet) across.

Its aqueous «paving» sparkles in the sunlight, although the water is sometimes wave-capped and can even become sombre and menacing, depending on the weather and the season. Lining the canal on either side is a parade of incredible buildings, brightly colored little houses alongside imposing stone palaces, dating from every period and exemplifying every architectural style.

Even the most distracted sightseer cannot help but be enthralled by the vision of charming buildings, squares, tiny canals extending into the shadows, gardens stolen from the threatening grasp of the sea, and a lovely gateway here and there, blackened and corroded by the weather and the water. It is no wonder that painters and poets, musicians and writers have always expressed such great admiration for the canal. Byron, Canova, Wagner, Hemingway, among hundreds of others, all spent lengthy periods of their lives on or near its banks.

Immediately to our left we note the **Santa Lucia Station.** The railway station was named after the Palladian church dedicated to Sta. Lucia, which was torn down in the middle of the 19th century to make way for the railroad linking Venice to the mainland. The railway bridge, officially inaugurated in 1846, was quite an engineering feat itself: 225 spans are supported by 75,000 pylons ancho-

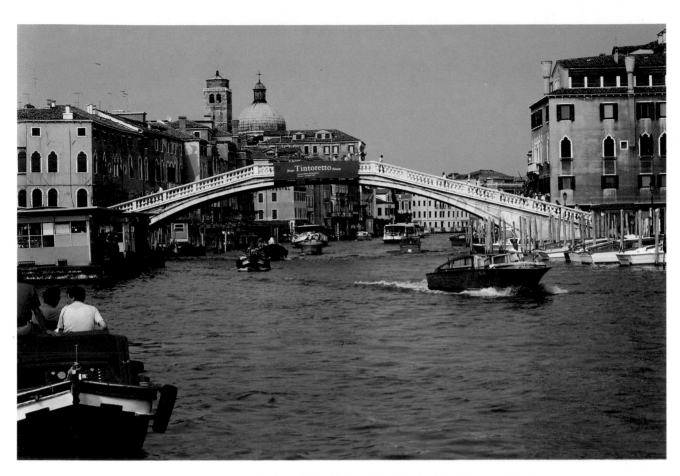

Ponte degli Scalzi over the Grand Canal; below: the church of San Simeone Piccolo.

red in the depths of the lagoon. On the other hand, the station is actually a recent construction opened to the public in 1954. From the station, going towards St. Mark's, we immediately note the attractive **church of San Simeone Piccolo** (also called San Simeone e Giuda) just to right of the station building.

The most striking part of the church is its huge copper dome and lantern, surmounted by a statue of Christ the Redeemer, whose distinctive green colour is due to the effects of weathering. The church dominates the whole first stretch of the Grand Canal, with its impressive staircase leading down to the water. Framing the entrance is an 18th century neo-Classical porch with Corinthian columns, designed by Giovanni Scalfarotto. The majestic gable crowning it is adorned with scenes of the martyrdom of saints Simeon and Judas sculpted by Francesco Penso. The first bridge we encounter on our way to St. Mark's is the **Ponte degli Scalzi**, also known as the Station Bridge. Made entirely of white Istrian stone, it was designed by Eugenio Miozzi and put up in 1934 to replace a metal structure built in 1858 by the Lombard-Venetian city administration. The single span bridge is approximately 40 meters (130 feet) long and rises approximately 7 meters (23 feet) above water level. On the left bank by the bridge we note the imposing Baroque façade of the **church of Santa Maria di Nazareth** (or Santa Maria degli Scalzi). Keeping our eyes riveted to the left side, we see the apse and belfry of the **church of San Geremia** which was first built in the 13th century and later remodeled in 1760. Its Romanesque belltower dates back to the 13th century and is thus one of the oldest in the city. Alongside the church is a grandiose 18th century

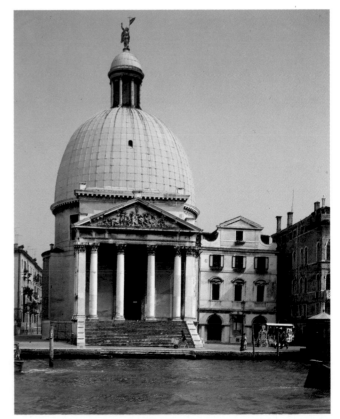

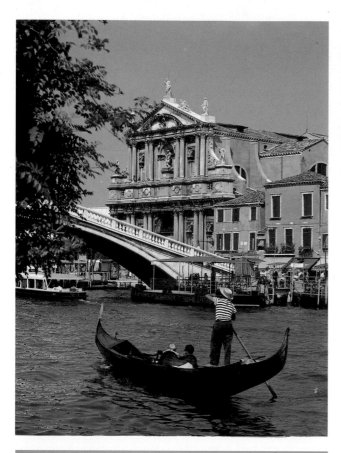

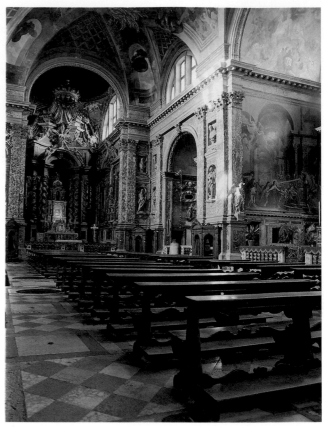

Above, from the left: *the church of Santa Maria di Nazareth and interior;* below: *Cannaregio Canal.*

Opposite page, top: *church of San Geremia;* below: *Fondaco dei Turchi.*

patrician palace, the **Palazzo Labia** whose interior was frescoed by Tiepolo. On the far corner is a statue of *St. John Nepomucenus* commissioned by one of the ladies of the Labia family. Still looking to the left, just beyond the statue of the saint we see the beginning of the **Cannaregio Canal**, the second largest in Venice after the Grand Canal. Farther on, this time on the right, is one of the most celebrated buildings in the Venetian Byzantine style, the **Fondaco dei Turchi**. The building was totally (and very arbitrarily) remodelled in the 19th century on the site of the 12th-13th century palace which was once the headquarters and trade center of the Oriental merchants stationed in Venice. Today it is the **Museum of Natural History**.

Once we have passed the **Rio della Maddalena** we encounter on the left **Palazzo Vendramin Calergi**, an outstanding example of Renaissance architecture. Begun by Coducci and completed by Lombardo in 1509, it was where Richard Wagner died on February 13, 1883. A series of fine palaces follows. The first is the 17th century **Palazzo Rouda**, with its completely remodelled façade. Just beyond we note the 16th century **Palazzo Gussoni-Grimani della Vida** attributed to Sanmicheli. Originally a fresco by Tintoretto adorned its façade, but like all other outdoor murals in Venice, this one too, corroded by brine and weathering, has been lost to us. Next we see the **Palazzetto De Lezze** with its tiny vine-covered façade, the 17th century **Palazzo Boldù** with its rusticated stone ground-floor, and lastly the **Palazzo Contarini-Pisani**, also from

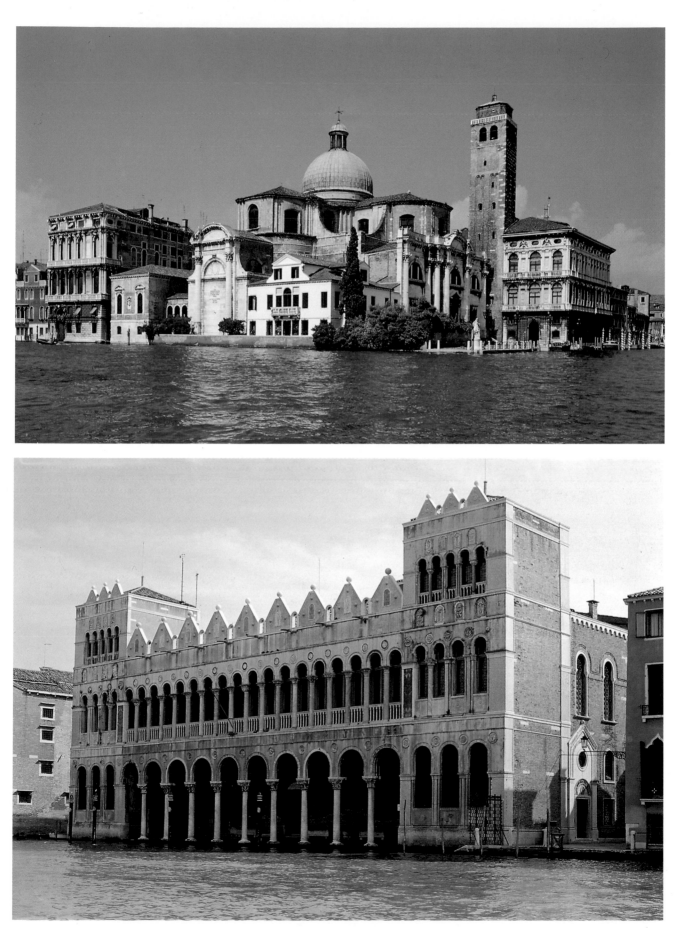

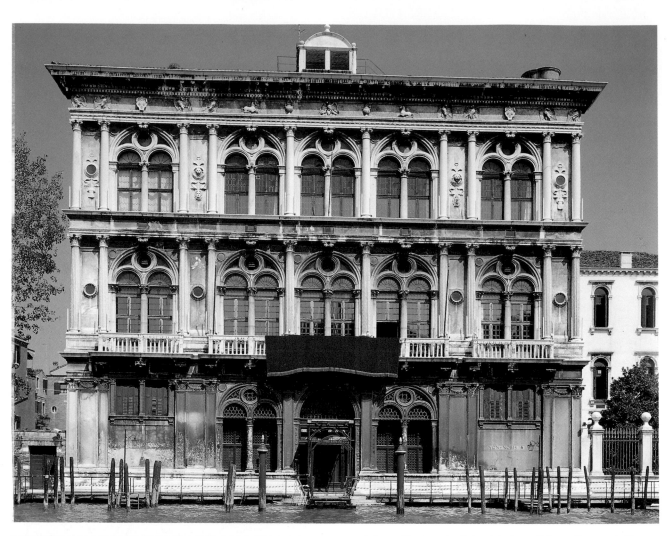

Palazzo Vendramin Calergi; below: *Palazzo Corner della Regina.*

Opposite page: *Ca' Pesaro.*

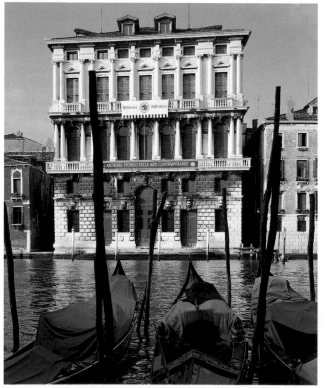

the 17th century, with its spacious portico on the canal side. Opposite these buildings is the majestic **Ca' Pesaro** acclaimed as Baldassarre Longhena's masterpiece of privately-commissioned architecture, built between 1679 and 1710. So great did the building costs seem at the time that the architect is said to have died from worrying about whether the project would ever be finished. The imposing façade rises upon a rusticated stone base surmounted by a double tier of windows set off by clusters of columns. The building today houses the International Gallery of Modern Art and the Oriental Art Museum. On the same side, right by the Ca' Pesaro, is the **Palazzo Corner della Regina**, a Classical style building designed by Domenico Rossi (1724) on the site of the former Palazzo Cornaro. Today it is the headquarters of a banking organization. Continuing along the left, we soon reach the most celebrated of the many remarkable buildings lining the Grand Canal, the Ca' d'Oro. After having been remodelled time and time again (and not always wisely) and passed from owner to owner, it came into the possesion of Baron Giorgio Franchetti who in 1916 donated the palace along with the art collection bearing his name to the Italian state. The façade, which today is white, was originally

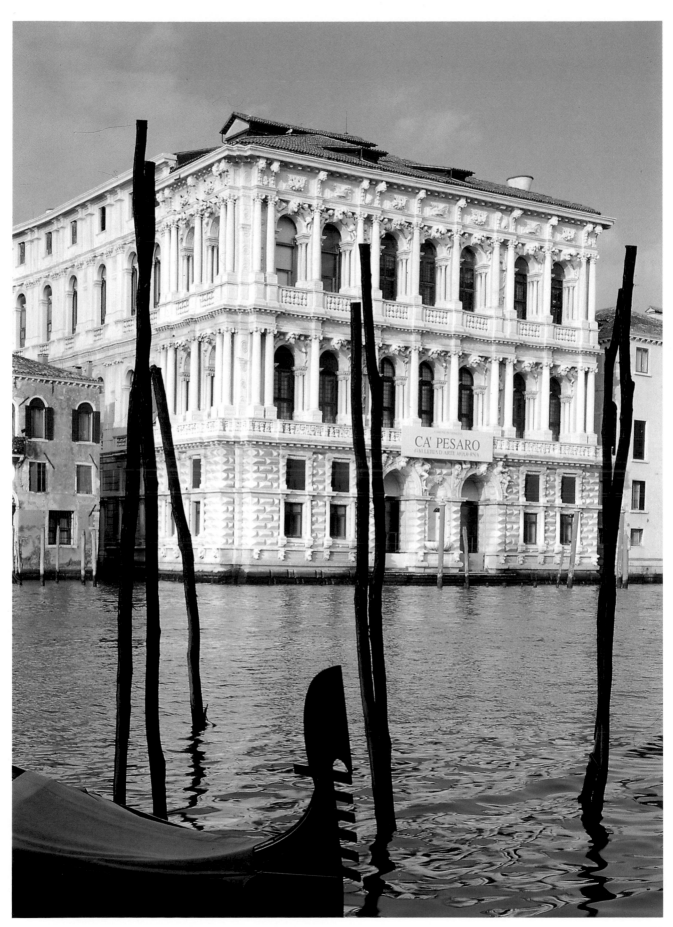

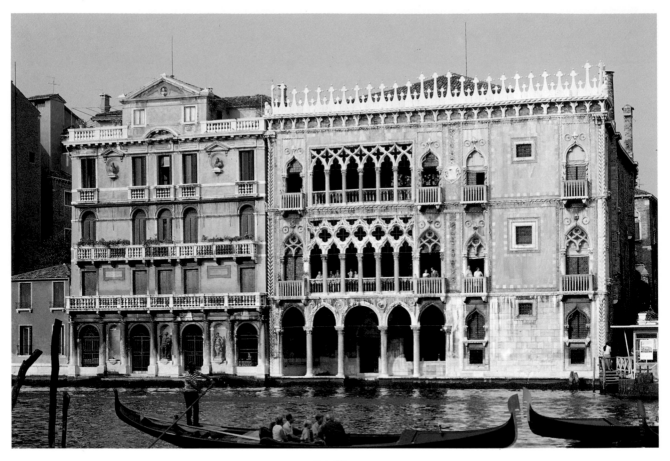

Ca' d'Oro.

gilded and this gave it its name–Ca' d'Oro, in fact, means Golden House. Built around 1440 for a nobleman, Marino Contarini, in a style which combines Byzantine influence with the Gothic pointed arch motifs, it looks like charming lace embroidery rising out of the Grand Canal.

On the ground floor is a portico which, except for the central round arch, is composed of graceful pointed arches. The two upper floors have delicately pierced loggias. The righthand section of the façade is more compact with fewer empty spaces, but it is in no way less elegant than the left side. Surmounting the façade is a crown of finely-wrought crenellation.

On the left is another palace, the **Palazzo Sagredo**, a late 14th century Gothic building, with an elaborate façade. Across the canal, we cannot help but notice a two storey brick structure jutting out a bit from the other buildings. This is the **Pescheria**, or **Fish Market**, which was built in 1907 by Domenico Rupolo after a design by the painter Cesare Laurenti. It opens on the Grand Canal by means of a spacious portico of slightly-pointed arches resting on columns which support a slanting roof to form the huge open loggia.

The building rises on the site of what has always been Venice's fish market. On the opposite side of the canal once more, we can make out the **Palazzo Michiel dalle Colonne**, with its distinctive ground floor colonnade. The denomination «of the Columns», is thought by some to derive from these very columns, whereas others believe it was added to the Michiel name because it was a member of the family who actually brought the columns standing on the Piazzetta di San Marco from the Orient. Immediately after the Pescheria, again on the right bank, we see

the impressive façade of the **Fabbriche Nuove di Rialto**. The building was put up in 1552 by Jacopo Sansovino and occupied by public offices having to do with trade and commerce. A bit beyond the Fabbriche Nuove we are struck by the colorful bustle of the open-air fruit and vegetable market. The building bordering the marketplace, known as the **Fabbriche Vecchie di Rialto** was erected by Scarpagnino in 1522 as the seat of the court house.

Facing the two *Fabbriche* is the **Ca' Da Mosto**. One of the most picturesque in Venice, this Venetian Byzantine-style palace was built in the 13th century. The Grand Canal now curves right and we are left speechless by the sight which meets our eyes upon passing the curve: before us is the Ponte di Rialto, or Rialto Bridge, in all its splendor. We shall discuss it in greater detail. But first, let us stop and take a look at the **Fondaco dei Tedeschi** (German Storehouse) to our left.

The building we see today was built in 1515 over the site of a pre-existing structure destroyed in a fire. It was designed by Scarpagnino in the Renaissance style with a spacious round-arch portico on the ground floor and a border of white crenellation on top.

Unfortunately, nothing remains of the frescoes by Giorgione and Titian that originally adorned the façade. To the right is the **Palazzo dei Camerlenghi**, which was originally the Treasury of the Republic of St. Mark and thus the city's financial center. The building was erected in the early 16th century by Guglielmo Bergamasco. And thus we have reached the bridge which is one of the most famous, if not the most famous, in the world, the **Ponte di Rialto**.

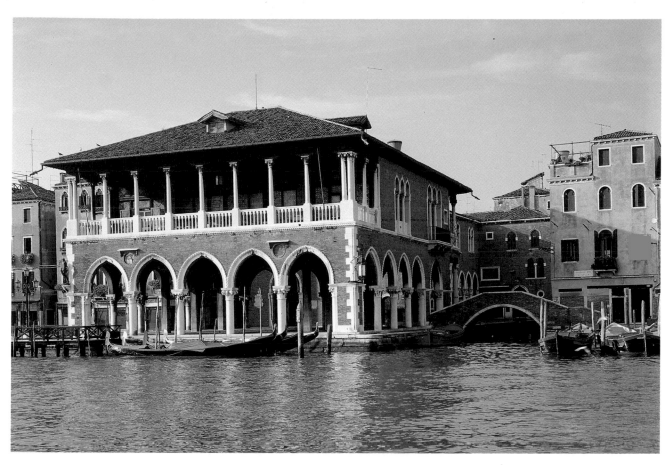

Pescheria; below: *Fondaco dei Tedeschi*.

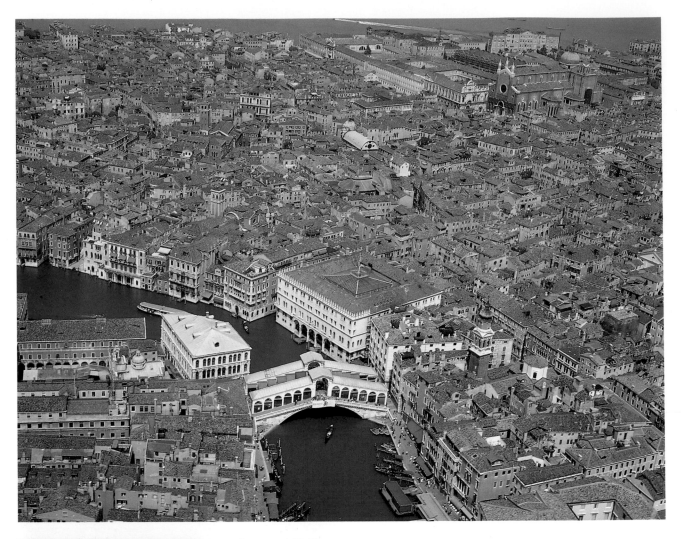

Aerial view of the Rialto Bridge; below: *inside the bridge.*
Opposite page: *gondolas along the Grand Canal.*
On the next two pages: *the Rialto Bridge seen from the Grand Canal.*

THE RIALTO BRIDGE

This is one of the best places to view the Grand Canal in all its charm. The Rialto is the oldest of the three bridges spanning the canal. Originally made of wood, it caved in in 1440 and was rebuilt, again of wood, but this time with the addition of several shops. It had a special mechanism which allowed the middle section to be raised, whereby even the tallest masted ships could sail through. It was somewhat unstable, though, and thus in the 16th century it was decided to build a new bridge. A competition was held, attracting the participation of such well-known architects as Michelangelo, Palladio, and Sansovino, all of whom worked on the project for years. Antonio Da Ponte, a relatively unknown architect in such illustrious company, was awarded the contract and designed the bridge which was not finished until 1592. The Rialto is a single span bridge measuring 27 meters (90 feet) (the narrowest crossing of the Grand Canal is here) and it reaches a maximum height of 7.3 meters (24 feet) at the middle. The two ends rest upon 12,000 pylons sunk into the muddy depths. The twenty-four shops lining the bridge are separated by a double arcade from which you can walk out onto the terraces.

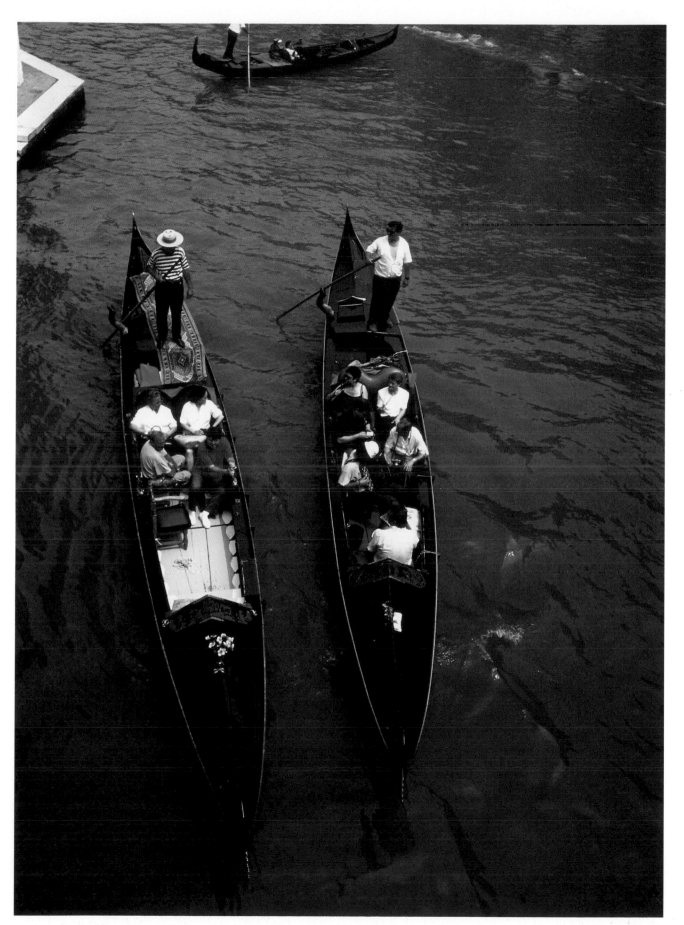

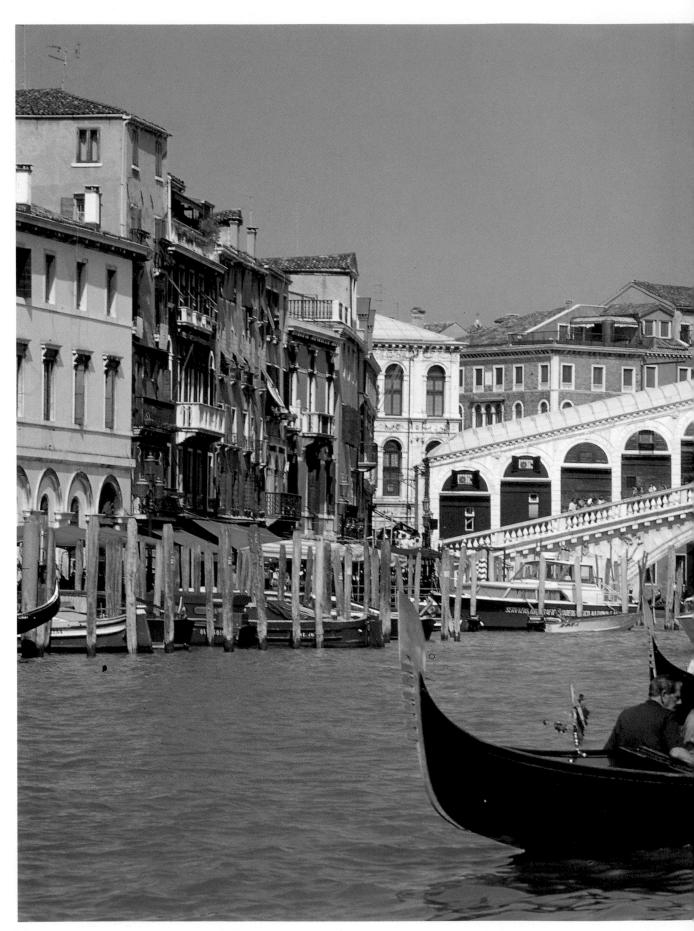

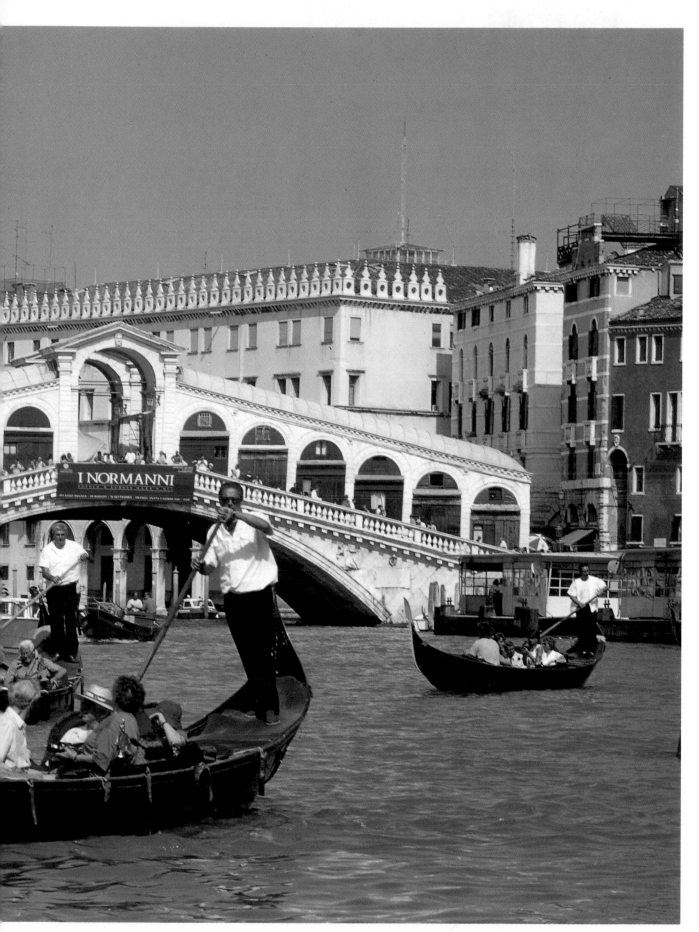

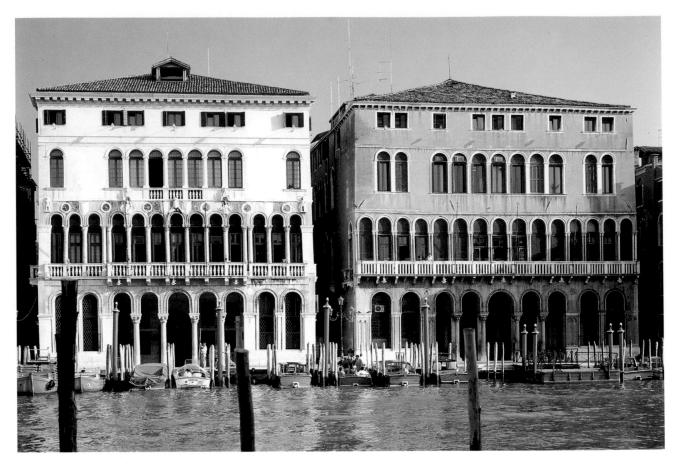

Palazzo Loredan and Palazzo Farsetti; below: *Palazzo Grimani.*

Opposite page, top: *Ca' Foscari;* bottom: *Palazzo Grassi.*

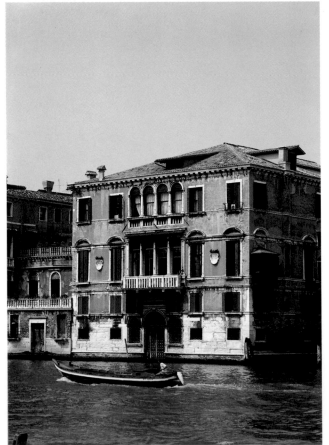

Just beyond the Rialto Bridge, on the right, is the **Palazzo dei Dieci Savi**, an early 16th century Renaissance building designed by Scarpagnino. Farther ahead on the left bank are the 13th century **Palazzo Loredan** and the 12th century **Palazzo Farsetti** (today the Venice Town Hall), typical examples of the Venetian Byzantine style. The lower floors, are characterized by graceful elongated arches running the length of the ground and second floors. The upper floors and balconies date from a 16th century alteration. On the same side, just a bit ahead, is a remarkable 16th century Renaissance building, Sanmicheli's masterpiece, the **Palazzo Grimani**. Today, the three-storey palace with its handsome arcading, is occupied by the Venice Court of Appeals. On the right bank is the **Palazzo Papadopoli**, a 16th century building designed by Giacomo dei Grigi in the Classical style. Next comes a fine 15th century Gothic palace, **Palazzo Bernardo**, in which the Duke of Milan, Francesco Sforza, resided for some time. Past the Rio San Polo on the right bank, is an

impressive 15th century building, the **Palazzo Pisani** with an intricate decorative motif adorning the center windows. Proceeding on the right, is the **Palazzo Balbi**, also known as *«Palazzo in volta de Canal»* (Palace on the Canal bend). Here the Grand Canal swings leftward and, on the right, by the Rio Ca' Foscari, is a famous 15th century Gothic building, the **Ca' Foscari**. Commissioned by Doge Francesco Foscari who ruled the Republic for over thirty years, it is now the Economics and Business School of the University of Venice.

The façade of Ca' Foscari has been acclaimed as one of the finest and best-proportioned in all of Venice. On the ground floor, six plain arched windows flank the great portal, while the upper floors are adorned with beautiful carved loggias whose lacy designs become more intricate with each storey. A bit farther along the left bank rises the 18th century **Palazzo Grassi**, built in 1718 by Giorgio Massari for the Grassi family of Bologna, and now occupied by the **Costume Institute**. The Classical façade has a rusticated stone ground floor and plain windows set off by simple balconies running the length of the two upper floors. Opposite Palazzo Grassi on the right bank is a beautiful example of Venetian Classical architecture, the **Palazzo Rezzonico**. The ground and second floors were designed by Baldassarre Longhena who actually started construction in 1660 commissioned by the Priuli-Bon family. The building then came into the ownership of the Rezzonico family, who commissioned Giorgio Massari, the same architect who worked on Palazzo Grassi, to finish it, although it was not fully completed until 1747. The façade has a rusticated stone ground floor, while the two upper stories are adorned with balconies and columns which set off the individual windows. Inside the palace is the Museum of 18th century Venice.

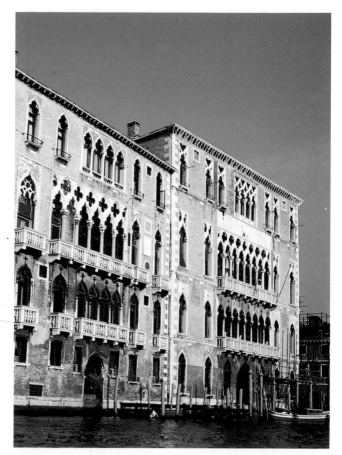

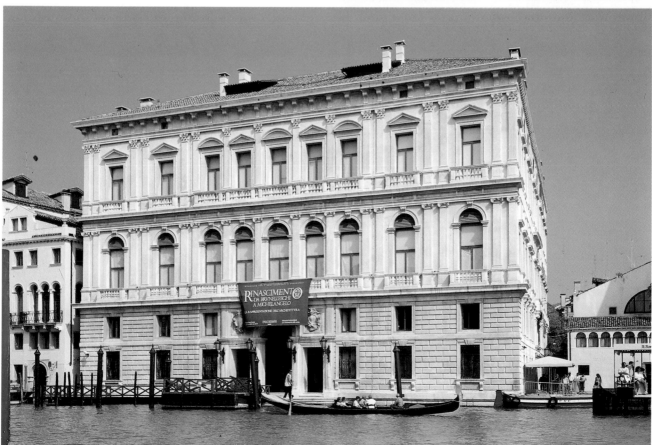

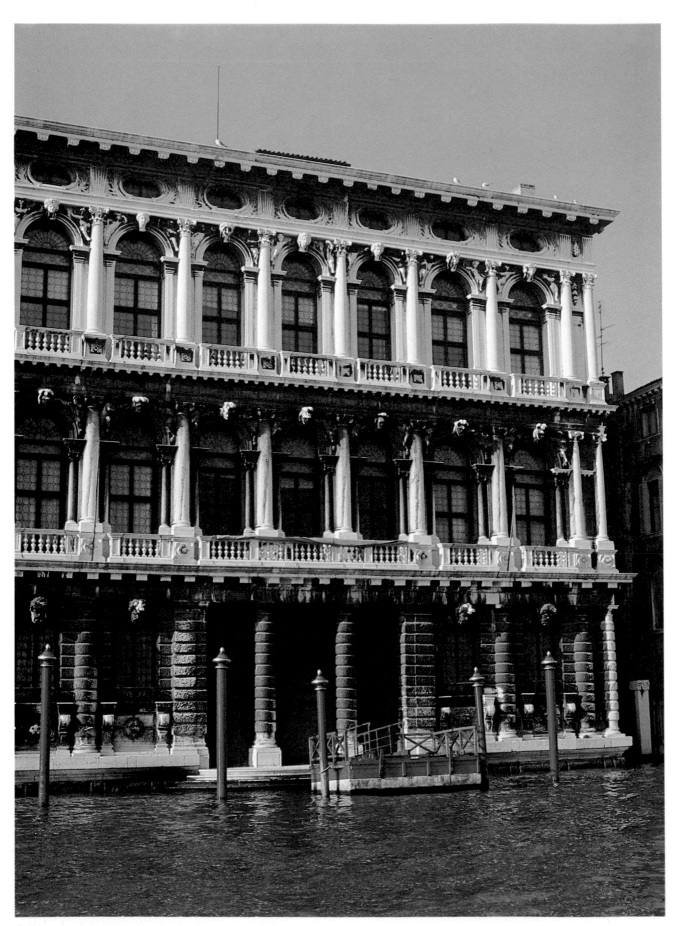

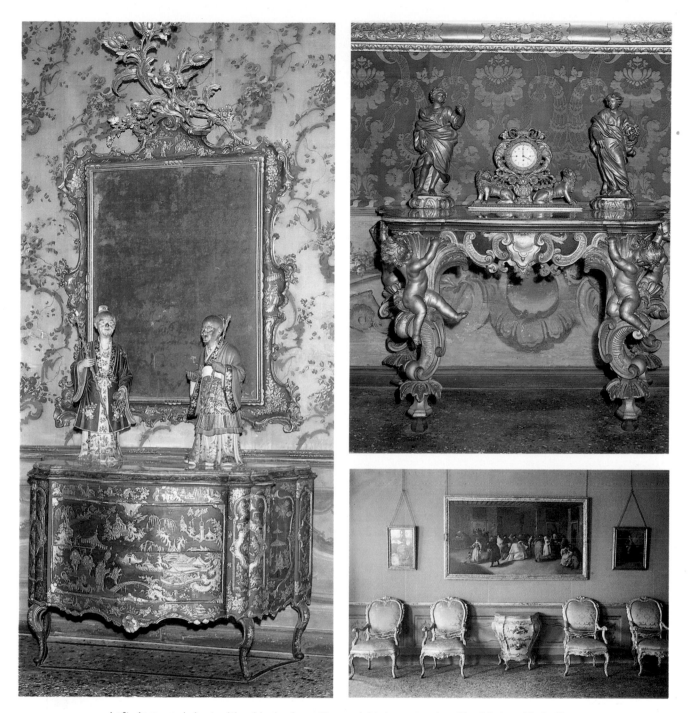

Left: *lacquered chest with «chinoiserie» patterns*; right, top: *console with gilded cupids*; bottom:
set of Venetian chairs.
Preceding page: *Palazzo Rezzonico*.

THE MUSEUM
OF 18TH CENTURY VENICE

The palace, originally belonging to a noble Venetian fam-
ily, Ca' Rezzonico, was the last home of Robert Browning
(the room where he died in 1889 has been left as it was).
The City of Venice purchased it in 1935 and used it for the
reconstruction of the interior of an 18th century patrician
dwelling, furnishing it with superb period pieces, vases,
and wall hangings. In addition it is filled with valuable
paintings by Carriera, the Tiepolos, and Longhi. The
Salone da Ballo (Ballroom) on the second floor is breath-
taking for its size, grandiosity, and stupendous *inlaid
furniture*. One of the best reconstructions is the so-called
«Villa del Tiepolo» which consists of the grisaille frescoes
painted in 1753 by Gian Domenico Tiepolo (son of Giovan
Battista) for his family estate in Zianigo on the Brenta
River. The reconstruction of the 18th century – perhaps
the most splendid in Venice's history – would hardly be
complete without a puppet theater, shown here together
with a complete set of period marionettes as well as a
Chemist's shop with a complete set of ceramic jars.

Entrance to the Academy.

THE ACADEMY GALLERIES

Five hundred years of Venetian art are displayed in the Accademia which, for homogenity, clarity of exposition, and quality, cannot be equalled anywhere. Its origins go back to 1750 when the Republic of St. Mark decided to endow the city with an «*Accademia di Pittori e Scultori*» (Academy of Painters and Sculptors) under the direction of Piazzetta. The original Academy occupied the Fondachetto delle Farine (Flour Storehouse), today the Port Authority, situated by the gardens of the former Royal Palace overlooking the harbor of St. Mark. In 1756 the Academy was granted official recognition and Piazzetta, by then an old man, decided to leave it in the capable hands of Giovan Battista Tiepolo. This was when the core of the first group of works by the pupils of the Academy was assembled. In 1807, during the French occupation, it was decided to transfer the art school and the works displayed in it to a more fitting place and the choice fell upon the *Scuola* and Church of the Carità (in the Campo della Carità) and upon the former monastery of the Lateran Canons, a building designed by Palladio in 1560 (but greatly altered since then). The collection grew considerably as numerous works from suppressed churches and monasteries continuously poured in. From 1816-1856 bequests from Molin, Contarini, Venier, and Manfrin brought in new treasures. Lastly, several works were returned from Austria after the Treaty of St. Germain was signed in 1919, and still other outstanding works were purchased by the Italian government. Somebody always asks why the name of the museum is Academy Galleries in the plural, even though there is only a single museum. Actually, the museum originally had two separate sections, one for paintings and the other for plaster casts used by the art students and the plural name has remained.

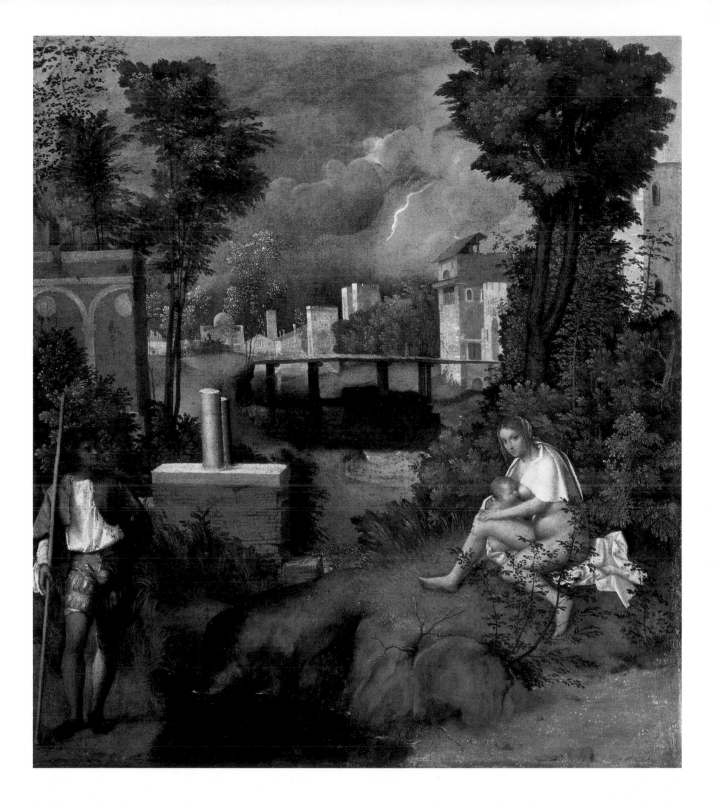

The Tempest, by *Giorgione*, c. 1507.

We hardly know anything about Giorgione's life. It is certain that he was trained in the school of Giovanni Bellini whose influence on his work was marked, and that he was also influenced by Antonello da Messina and Leonardo. The Tempest, acclaimed as Giorgione's masterpiece, is one of the hardest to decipher iconographically, and one of the first examples of his revolutionary new painting style. Its title dates from 1530 when it was described as a tempest scene by Marcantonio Michiel who saw it hanging in the home of its owner, Gabriele Vendramin. This, however, is certainly an oversimplification of the subject which, as we said before, has always been extremely controversial. The 19th century theory was that it is simply a self-portrait of the artist and his family, a later one that it represents an episode from the Thebaid of Statius, while the most recent and most probable is that the theme was inspired by a 15th century romance popular in the intellectual circles of Giorgione's day, the *Hypnerotomachia Poliphili*. Accordingly, the seated female nude is Venus nursing her son, Cupid, the clothed male figure is the hero of the story, while the landscape perfectly matches the setting described in the book.

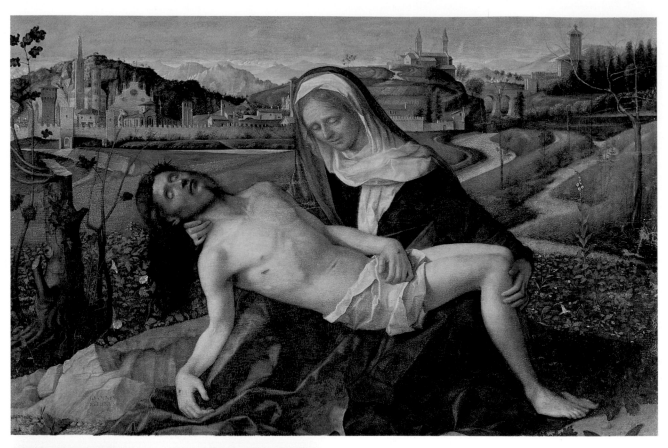

Pietà, by *Giovanni Bellini*.
Giovanni Bellini's activity spanned the second half of the 15th century and the beginning of the 16th. His painting marked the passage from the archaic Venetian style, still under the influence of High Gothic, to the great Venetian flowering of the 16th century. He was influenced by both Italian masters such as Mantegna and Antonello da Messina, and foreign ones, mainly of the Flemish and German schools. His painting is full of contrasts – his figures are solitary and peaceful, his colors bright and sapiently shaded, and his symmetrically arranged figures have a sweetness about them. Melancholy, rather than tragedy, prevails. This Pietà dates from the early 1500s, the artist's mature period. The Virgin, portrayed as an old woman, appears in the middle holding the limp body of her Son. The background consists of a lonely landscape setting with an imaginary walled city (a mixture of 15th century Ravenna and Vicenza).

Virgin of the Zodiac, by *Cosmè Tura*, c. 1450.
Cosmè, a native of Ferrara, worked for the d'Este dukes at the Court of Ferrara for many years. His painting is a striking blend of Ferrarese «surrealism», Tuscan humanism (Classical references), and Northern European palette. This blend of completely different elements gave birth to a wholly personal style in which line prevails over color. The painting's name comes from the signs of the zodiac visible behind the Virgin. Of the original twelve, only four have come down to us.

St. Jerome and a Worshipper, by *Piero della Francesca*, c. 1450.
One of the foremost masters of 15th century Tuscan art, Piero viewed man and nature, inexorably bound together, as part of the greater harmony of the universe. He was fascinated by perspective, which he used as a means of transporting his concept of universal harmony into painting. Although the St. Jerome is an early work, it already reveals the features that would remain constant throughout his artistic career. It was commissioned by Girolamo (Jerome) Amadi, who belonged to a wealthy Venetian family (the family, however, was from Lucca – and thus of Tuscan origin like Piero). The figures, sculptural and vigorous, are set in a delightful Tuscan landscape.

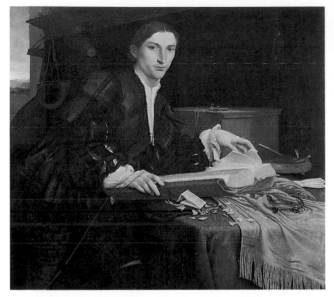

Portrait of a Gentleman, by *Lorenzo Lotto*, c. 1526.
Long underestimated, first by his contemporaries and later by art historians, Lorenzo Lotto is now considered a master in the tradition of Antonello da Messina and Dürer, diametrically opposed to that of Giorgione. In fact, Lotto emphasizes line and imbues his canvases with cool tones rather than the blended, warm colors favored by his contemporaries, Giorgione and Titian.

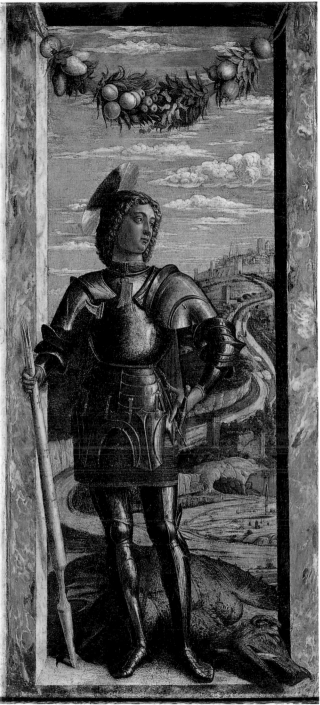

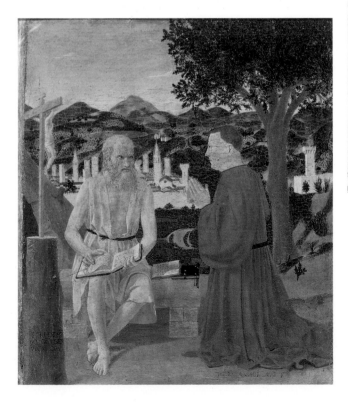

St. George, by *Andrea Mantegna*, c. 1468.
Andrea Mantegna trained under the Paduan master Squarcione in a workshop open to all kinds of cultural stimulation. Widely travelled, he had been able to see works by Tuscan masters such as Andrea del Castagno, Paolo Uccello, and Donatello. His strictly humanistic background is reflected in a heroic conception of antiquity and man, whom he interprets as dominator and creator of history. Despite the small size of the painting, the figure of St. George with the limp body of the slain dragon at his feet rises monumentally, against the lovely background landscape.

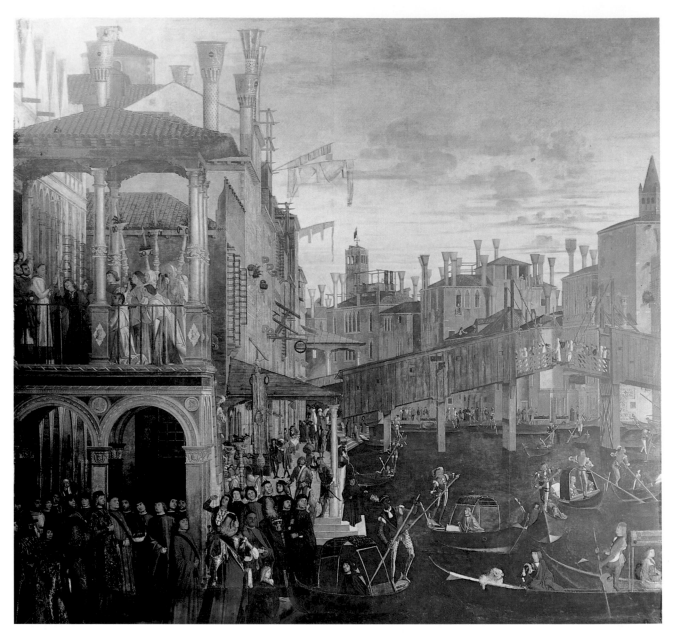

Miraculous Healing of a Possessed Man, by *Vittore Carpaccio*. Painted in 1494, this is the most famous of the eight canvases comprising the cycle of the Miracles of the Relic. The lively motion of gondolas along the Grand Canal, bizarre chimneys and the impressive view of the Rialto Bridge that was still made of wood, are the main focus of interest in this painting.

Portico and Courtyard, by *Canaletto*, 1763. Canaletto's studies, and his refined «vedutismo» fit into the general context of rationalism, the desire to create order that highlighted XVIII century Enlightenment thought. The perspective technique he learned in his early years as a set designer are put to excellent use, in the clear, rigorous scenes depicting mainly Venetian urban views. The perspective study of which this **Portico and Courtyard** is but one example, is merely one aspect of his scientifically sound research on the possibilities of how light and atmosphere could be rendered by color.

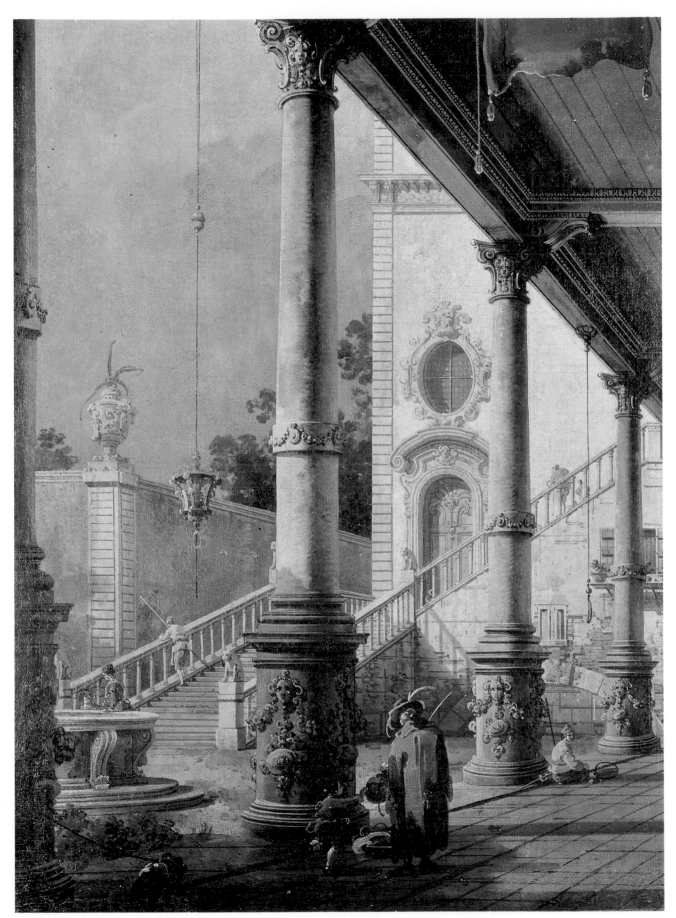

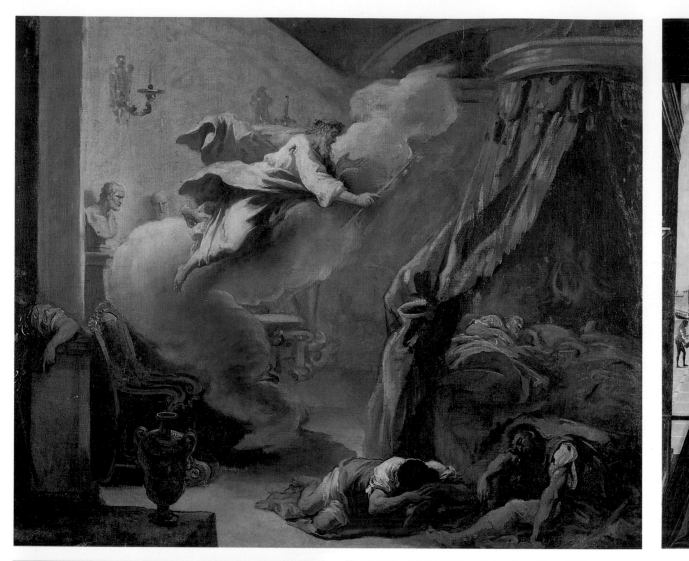

The Dream of Aesculapius, *Sebastiano Ricci*, 1710 ca.
Sebastiano Ricci and his brother Marco were key figures in late 17th century Venetian art. He travelled widely and was influenced by Luca Giordano's decorative techniques and Magnasco's dramatic and intense style. He favored, pale, light colors that he «borrowed» from Veronese and used in his lively, dynamic compositions.

Pietà, *Titian*.
This is the last painting by the great master who dominated an entire century of Venetian art. It was begun for the church of Santa Maria dei Frari, but was still unfinished when the master died in 1576. Palma the Younger completed it, added finishing touches and the angel and did his best to maintain Titian's style. This late work of the master is characterized by generally darker tones and elongated, weakened figures.

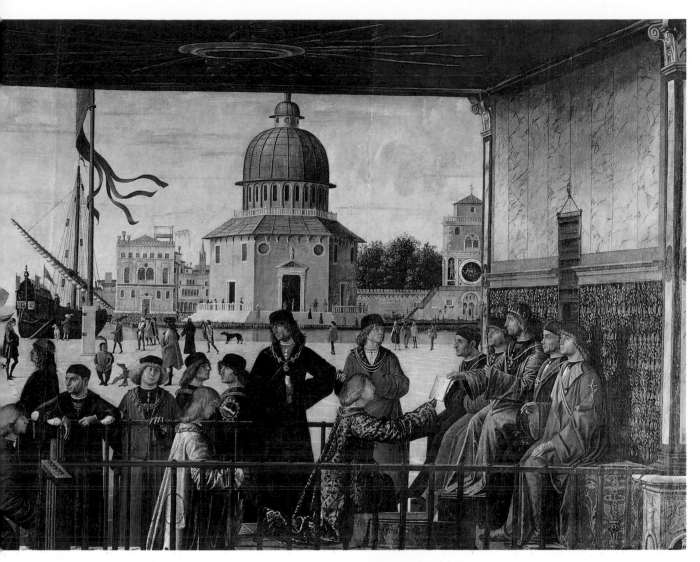

The English Ambassadors at the Court of Brittany, by *Vittore Carpaccio.*

The paintings displayed in this room constitute one of the most famous 15th century Venetian cycles. Painted for the Oratory of the Scuola di Sant'Orsola between 1490 and 1496, they recount a story from an apocrypahl text, the Golden Legend of Jacobus de Varagine. Ursula, a princess of Brittany, was asked by Hereus, pagan heir to the English throne, to be his wife. Ursula accepted the proposal on the condition that Hereus become a Christian and that he accompany her and 11,000 other virgins on a pilgrimage to Rome and the main Christian shrines around the world. The pilgrimage, however, never got any farther than Cologne where Ursula and her companions were attacked and slain by the Huns. Carpaccio's narrative bent and lively imagination are here revealed at their best.

Rape of Europa, by *Francesco Zuccarelli,* c. 1745.
Another of the 18th century "picturesque" landscapists, Zuccarelli is nevertheless very different from his contemporary Ricci. Rather than dramatic, far-reaching views, Zuccarelli's landscapes represent airy, idyllic scenes of Arcadia, bearing the clear imprint of the academic style of his day.

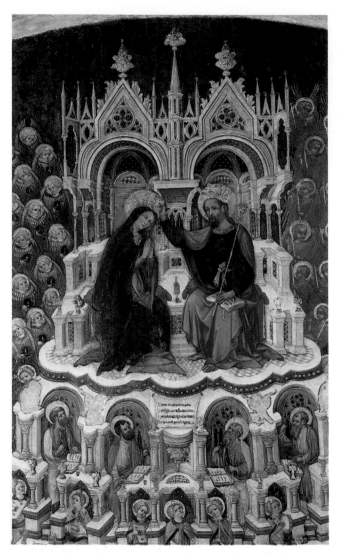

Coronation of the Virgin, by *Jacobello del Fiore*, 1438.
This is one of the last works by Jacobello who was trained in the Venetian- Byzantine milieu, and gradually evolved toward the High Gothic style. He spent the later years of his life working for the *Repubblica di San Marco*, turning out brightly-colored, very decorative paintings. This Coronation was painted for the Cathedral of Ceneda, today known as Vittorio Veneto.

Isola di San Giorgio, by *Francesco Guardi*.
Guardi's highly-personal version of *vedutismo*, characterized by freer, more vibrant brushstrokes, is the exact opposite of Canaletto's transparent, photographic «objectivity». In fact, how much Tiepolo and Magnasco influenced his more painterly style is evident in all his landscapes, including this one. Here, the Isola di San Giorgio appears immersed in a thick fog rather than outlined against a sunlit sky. The immediacy and emotional attachment of the artist to his subject almost seem to foreshadow 19th century Romantic painting which would be characterized by these very same traits.

Feast in the House of Levi, by *Paolo Veronese*, 1573.
This work was commissioned by the Dominican monks of the Monastery of San Zanipolo in Venice to replace Titian's Last Supper, destroyed by fire in 1571. Originally, Veronese had intended the scene to represent the Last Supper, but the Inquisition Court was scandalized at the presence of dwarfs, animals, «*todeschi e buffoni*» (Germans and clowns) in such a solemn representation and ruled that the figures and settings were «*non convenienti et proportionati*» (inappropriate and unbecoming). The Last Supper, was thus rechristened Feast in the House of Levi (a marginal episode recounted in the Gospels referring to a banquet given by the Levite Matthew after he had been called to be an apostle). According to tradition, the figure in the center foreground next to the Moorish servant-boy is a self-portrait of Veronese.

The Banquet of Epulones, by *Bonifacio de' Pitati*, c. 1540.
Bonifacio de' Pitati, a native of Verona, studied under Palma the Elder, but later was greatly influenced by Titian and Tintoretto, the great Venetian masters. This is especially noticeable in this late work, one of his finest. The subject is a parable from the Gospels: in the center we see Epulones feasting and merry-making, totally ignoring the poor beggar, Lazarus.

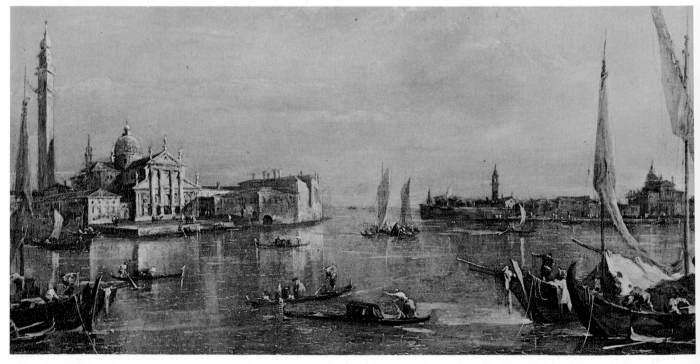

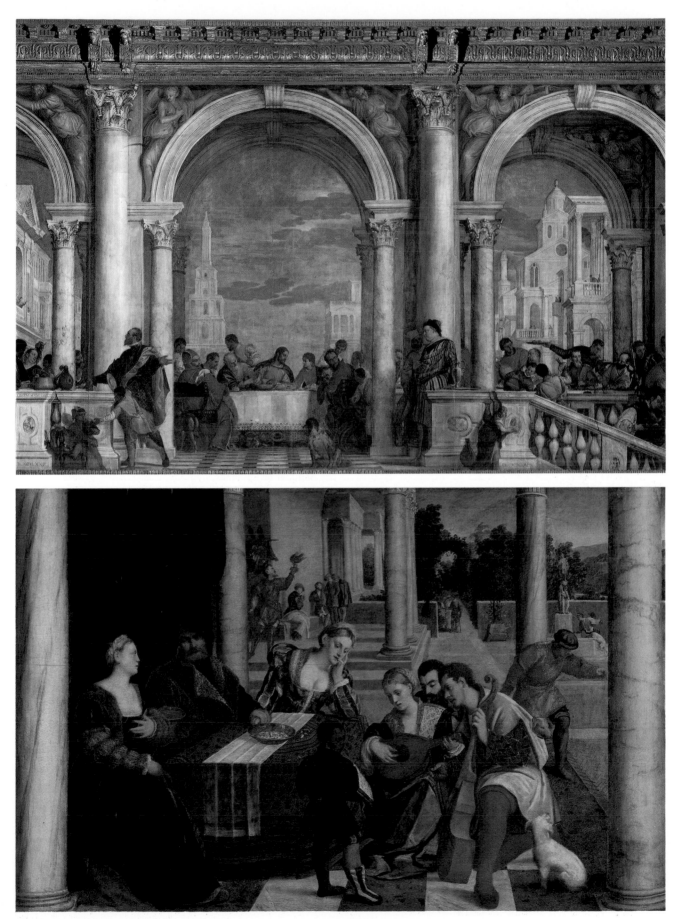

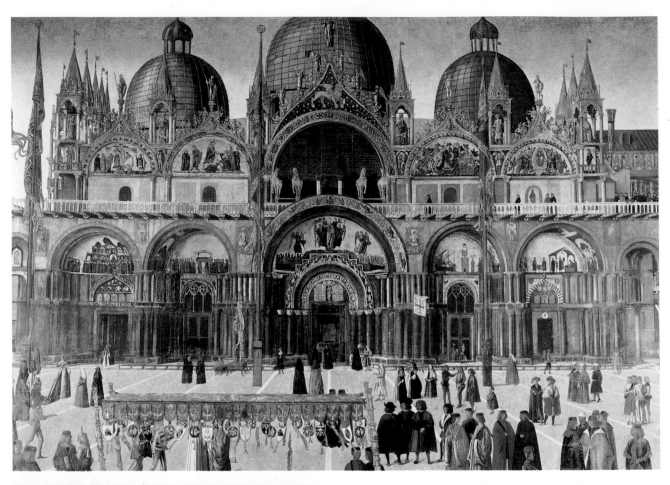

Procession of the Relic in Piazza San Marco, by *Gentile Bellini*, 1496.

During the annual procession in Piazza San Marco which took place on April 25, 1444, as it did every year on St. Mark's feast day, a merchant from the city of Brescia, Jacopo de' Salis, reverently knelt in front of the relic to pray for the recovery of his dying son, and his prayers were answered. In addition to its considerable aesthetic qualities, the painting is also a fascinating historical document. Gentile's wealth of details create a «photographic» description of how Piazza San Marco appeared at the end of the 15th century. In the background, the Basilica is aglow with its original gilt decoration and mosaics (today, only the mosaic of the first arch on the left is extant). On the left side, past the Procuratie Vecchie, there is no clocktower for, in fact, it was in the process of being built at the time. Lastly, note the herringbone pattern of the paving stones, which would be changed in the 18th century, and the trimullioned windows of the Doges' Palace, which would later be replaced.

The Fortune-Teller, by *Giovan Battista Piazzetta*, 1740.

This genre painting belonging to the artist's mature period shows him at his vital, exuberant best, especially in his masterful handling of color. The strong light and shade contrasts created by vigorous dabs of paint are very effective and make this one of the finest examples of 18th century painting.

A bit farther on to the right is the 15th century Gothic **Palazzo Loredan dell'Ambasciatore** with its handsome façade. Inside the niches on either side are 15th century Lombard sculptures. Facing Palazzo Loredan is another 15th century Gothic building, **Palazzo Falier**, characterized by loggias on either side. We have now reached the last of the three bridges spanning the Grand Canal, the **Ponte dell'Accademia**.

This bridge too has only a single span. It is made of wood and metal and has recently been completely restored. Before 1930, a 19th century all metal bridge, stood in its place, but it was torn down because it clashed too much with the rest of the Grand Canal's harmonious style. Beyond the bridge on the left is a late 19th century building, the **Palazzo Cavalli Franchetti** whose façade was inspired by the Venetian Gothic style. On the opposite bank is another fine Gothic building, the **Palazzo Da Mula** which dates from the end of the 15th century. Farther on, on the same side, is a palace set in a lovely green park, the **Palazzo Venier dei Leoni** which houses the fabulous Guggenheim collection.

Facing it is the attractive **Casina delle Rose** (Rose House) in which two celebrated Italians, Canova, the 18th century sculptor, and D'Annunzio, the early 20th century

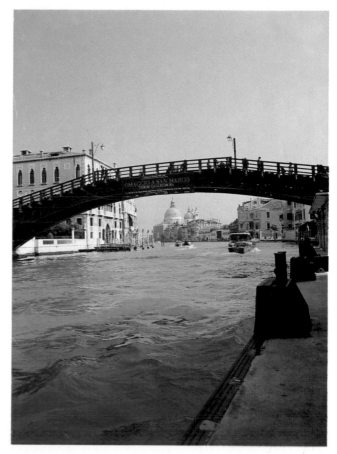

Right: *the Accademia bridge;* below: *Palazzo Cavalli Franchetti.*

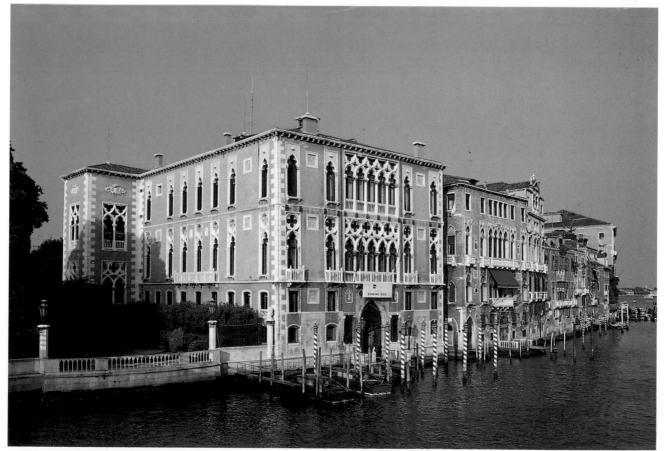

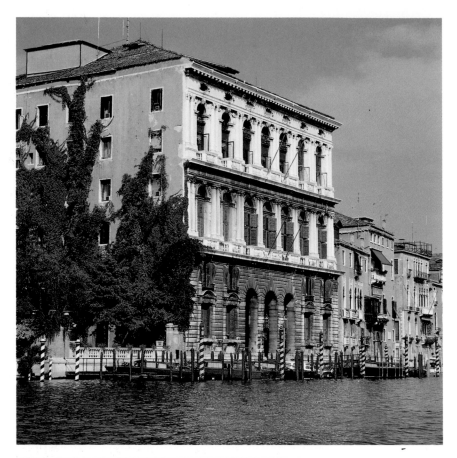

Left: *Ca' Granda*; below: *Palazzo Venier dei Leoni*, home of the Guggenheim Collection of modern art.

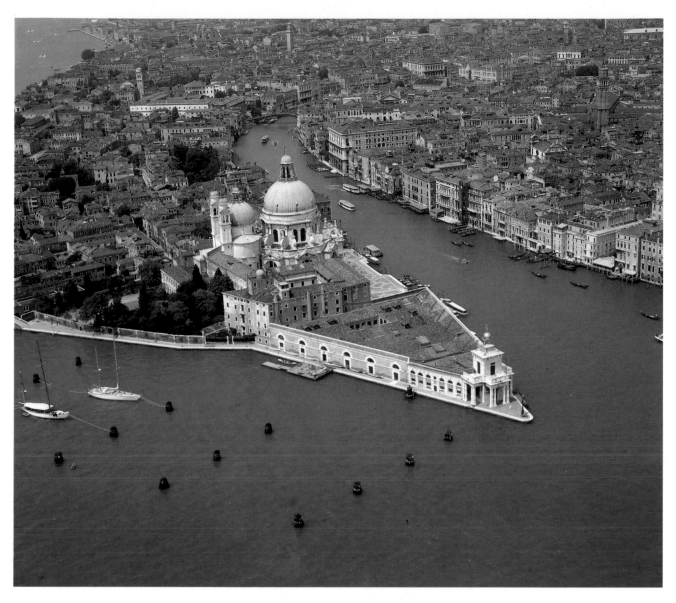

Aerial view of the Punta della Dogana.

writer, lived at various times. On the left is the headquarters of the local prefecture, **Palazzo Corner**, also known as **Ca' Granda** (Big House) whose impressive size undoubtedly gave it its nickname. Jacopo Corner commissioned the architect Sansovino to build it in 1535. Three centuries later, during the Lombardy-Venice period, it was occupied by the Austrian governor. Opposite the Ca' Granda is the **Palazzo Dario**, a Renaissance building erected by Pietro Lombardo in 1487, whose façade is adorned with multicolor decorative motifs and marble ornamentation.

Next on the left is the 15th century Venetian Gothic **Palazzo Contarini Fasan**, which has been dubbed «Desdemona's House». On the right we are struck by the sight of the majestic **church of Santa Maria della Salute** looming before us. This magnificent building is the masterpiece of Baldassarre Longhena, whose contribution to the appearance of the Grand Canal was considerable. Beyond the church is the **Punta della Dogana** upon which stands a 17th century tower surmounted by a globe supposed to bring good luck. From the 15th century onwards, duty on goods arriving from overseas was exacted on this spot.

We are now at the place where the Grand Canal flows into the huge stretch of water in front of St. Mark's. As soon as we get off our vaporetto at the **Pontile di San Marco**, we are standing before a Lombard-style building erected in the 15th century. In the past it was occupied first by the *Magistrato della Farina* (Flour Magistrate) then by the Academy of Painters and Sculptors (from 1756 to 1807, when it was headed by G. B. Tiepolo), and at present it is the headquarters of the Venice Port Authority. Inside is a hall with a ceiling fresco by Jacopo Guarana (1773) depicting the *Triumph of Art*. Proceeding, we soon arrive at the **Giardinetto del Palazzo Reale**. The park is on the site of the building which served as a storehouse for wheat. At the end of the garden we see the imposing **Palazzo della Zecca** designed by Sansovino in 1535. The rusticated stone arcading, Doric on the first and Ionic on the second floor, conveys an effect of stateliness and power, quite fitting for the Mint of the Republic of St. Mark. Here, in fact the Venetians minted their celebrated *Zecchini d'oro* (gold sequins), the counterpart of the equally-renowned gold florins of Florence, both of which were widely circulated throughout Europe and even the Orient.

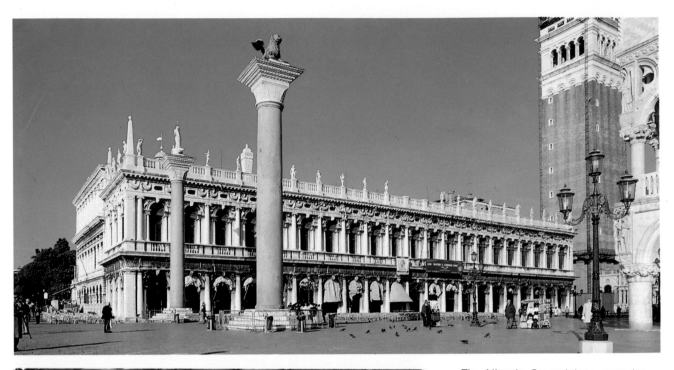

The Libreria Sansoviniana; opposite:
cover of a codex with enamels and
precious stones.

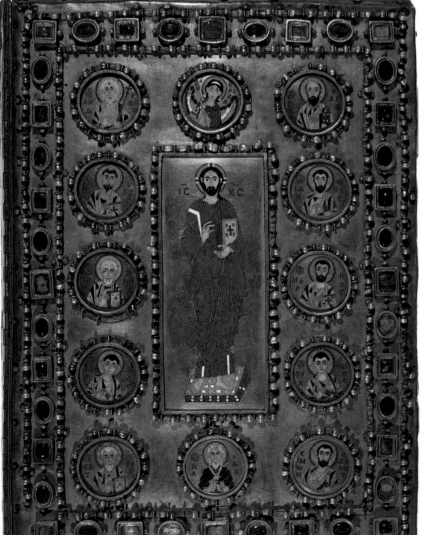

SANSOVINO LIBRARY
(Libreria di San Marco)

The Library takes up the whole west
side of the Piazzetta. Considered San-
sovino's masterpiece, it was defined
as «the most sumptuous ever built»
by the architect Palladio, while the
writer Pietro Aretino remarked that
it «was beyond envy». The construc-
tion of a library to house the fabulous
collection of rare books donated to
the city by Cardinal Bessarione (who
had been granted asylum here) was
decided by the Senate of the Republic
in 1536.

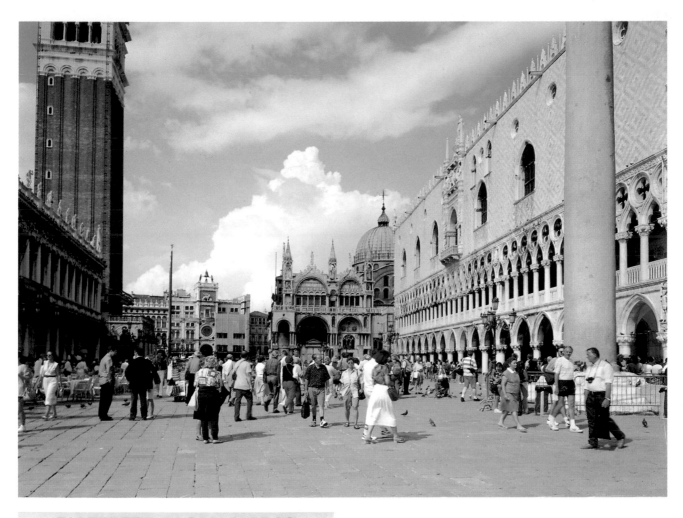

PIAZZETTA DI SAN MARCO

Piazzetta di San Marco; below: *the Columns of San Todaro and the Lion of St. Mark.*

The Piazzetta serves as the simple but elegant antechamber to the grandiose Piazza San Marco. Two of the city's foremost monuments face onto it: the Doges' Palace to the east and the Libreria Sansoviana to the west. Originally, a market for foodstuffs occupied this area, but then in 1536 the reigning doge decreed that the space should be kept clear.

By the quay are two monolithic columns (one with the Lion of St. Mark and the other with a statue of St. Theodore), both brought to Venice from the Orient in 1125. The two columns were set up on this spot in 1172 by a certain Niccolò Starantonio who had previously built one of the earliest wooden Rialto Bridges. The statue of St. Theodore (Todaro, in dialect) the first patron saint of Venice, standing atop the column, is actually a collage of different parts from different palaces, whereas the bronze lion on the second column is believed to be of Eastern, some even claim Chinese, origin. The Piazzetta was also the scene of public executions and between these columns both humble citizens and high-ranking personages were dealt the death sentence. Two of them passed into history. One was Pietro Faziol, known as «*Il Fornaretto*» (the baker's boy) who was executed after being unjustly charged with having killed a nobleman. Since then two oil lamps have been kept burning in his memory on the façade of St. Mark's nearest the Piazzetta. The other was the Count of Carmagnola, charged with high treason and executed on the same spot.

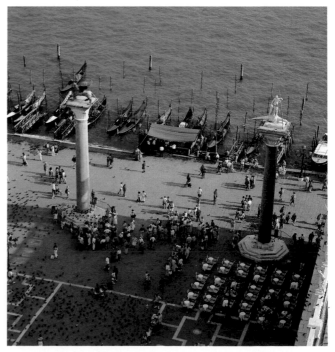

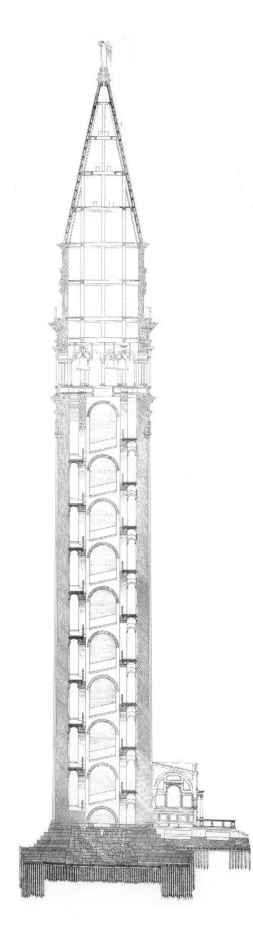

This is the oldest belltower in Venice, having been built over Roman foundations, starting from the time of Doge Pietro Tribuno (888-912) and then on and off over the years. Among the numerous artists who had a hand in it were Niccolò Barattieri and Bartolomeo Malfatto (the bell chamber), Proto Bon and Giorgio Spavento. For centuries it withstood the onslaught of storms and earthquakes. Then, at 10 am on July 14, 1902, weakened by centuries of vicissitudes and less than perfect workmanship, it suddenly collapsed, luckily without causing a single victim or damage to the nearby monuments (except for Sansovino's Loggetta which was shattered into fragments and buried beneath the rubble). The loggia was put back piece by piece and the belltower itself was reconstructed exactly as it had been on the same spot. It was re-opened to the public on the feast-day of St. Mark, the patron saint of the city, in 1912. At the foot of the belltower is the marvelous three-arched loggetta built by Sansovino between 1537 and 1549 to replace a 13th century one which had been transferred from the San Basso district to the Piazzetta. In 1569 it housed the Armed Guard of the Republic when the Greater Council was in session. The four bronze statues in the niches of the façade depict *Apollo*, *Mercury*, *Pax* and *Minerva*.

Left: *The northside of the belltower of St. Mark and the Loggetta. The pilings that support its weight are visible at the bottom.*
Below: *the Loggetta Sansoviniana.*

Facing page: *view of St. Mark's square.*

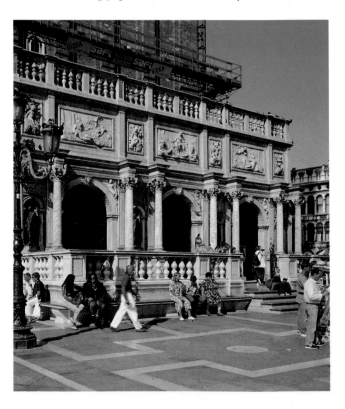

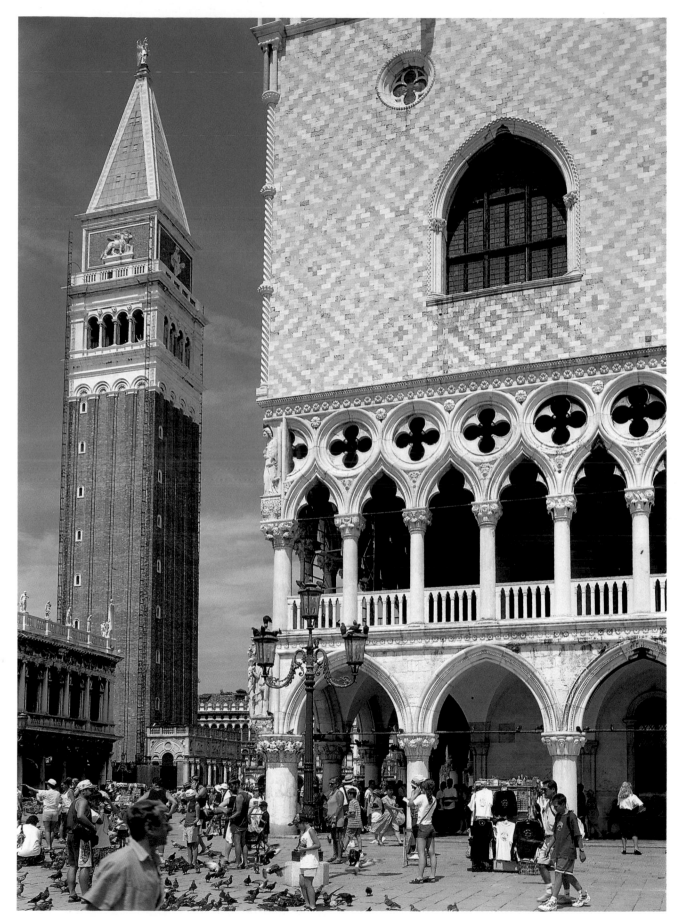

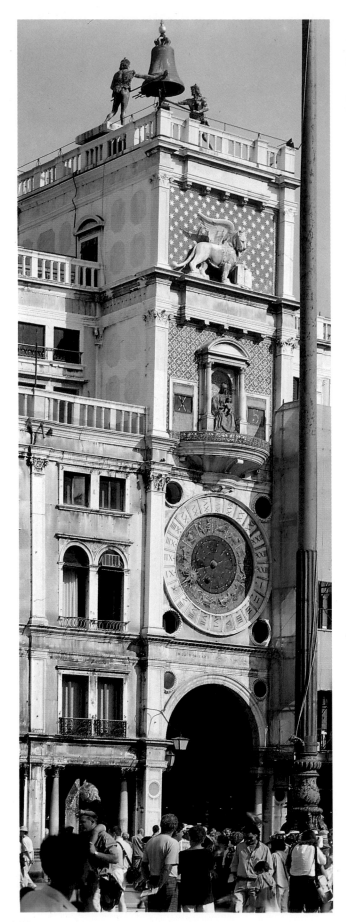

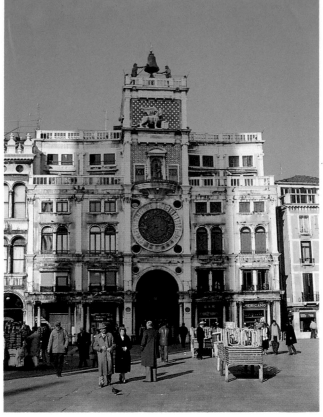

On this page: *two views of the clocktower*.

THE CLOCKTOWER

The Clocktower was built by Mauro Coducci between 1496 and 1499. The wings were added between 1500-1506, it is believed after a design by Pietro Lombardi, and later raised c. 1755 by Giorgio Massari. Above the tower is a terrace which contains a famous *bell*. The bell is sounded by the hammers of two male figures, dubbed *Moors*, due to the dark patina of the bronze they were cast in. They have been striking the hours in Venice for over four centuries (the figures were cast by Ambrogio de la Anchore in 1497). Beneath the top of the tower is the symbol of the city, the winged lion. Below it is a semi-circular terrace with a niche and two side entrances. The niche contains a gilded copper statue representing the *Virgin and Child*, which has been attributed to the sculptor and goldsmith Alessandro Leopardi born in the second half of the 15th century. Each year on the Feast of the Ascension (which comes 40 days after Easter) and during the whole week of the festivities marking the holiday, when each hour strikes, an angel, followed by the three magi go in and out the side doors, pass in front of the Virgin and bow to her. Below the semi-circular balcony is the huge dial of the complex clock works placed there at the end of the 15th century. It was created by two craftsmen, Giampaolo and Giancarlo Ranieri father and son, from Parma.

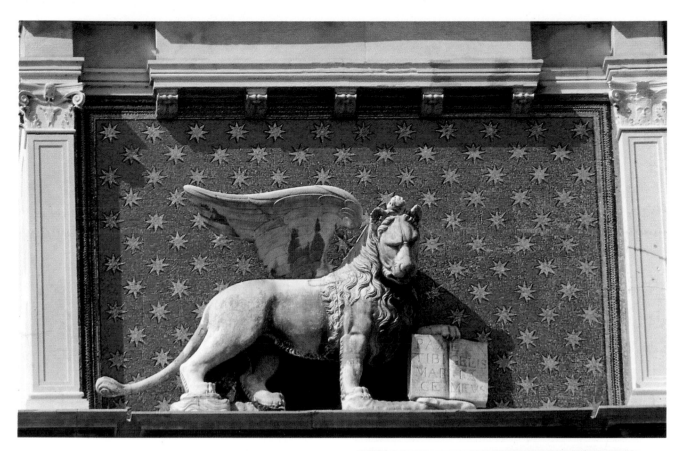

The winged lion, symbol of Venice; below: two Moors atop the tower; below, right: the great clock by Giampaolo and Giancarlo Ranieri (late XV century).

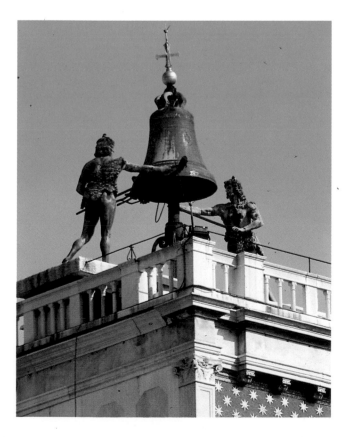

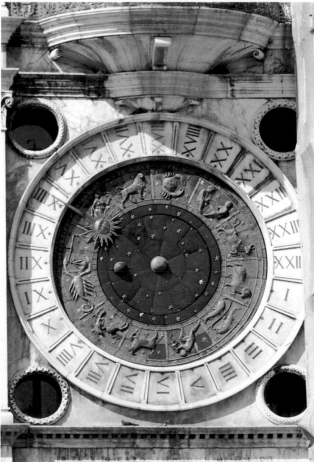

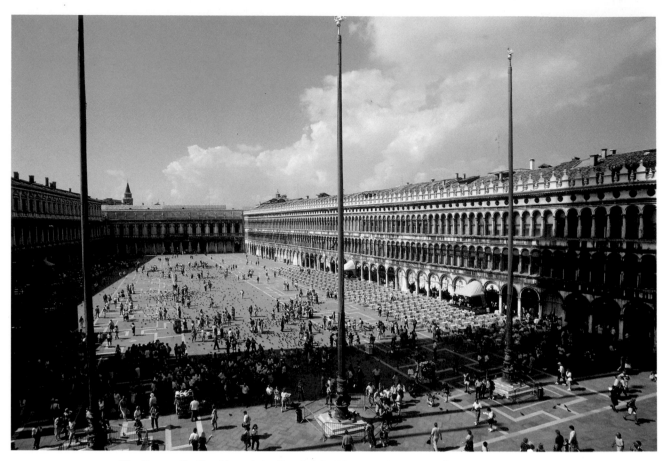

The Procuratie Vecchie and the Napoleonic Wing, head-quarters of the Correr Museum.

PROCURATIE VECCHIE – NAPOLEONIC WING – PROCURATIE NUOVE

Extending the length of the Clocktower side of the square is the building known as the **Procuratie Vecchie** which has fifty arches on the ground floor level and two upper floors of loggias. It was begun between the end of the 15th and first half of the 16th centuries by Mauro Coducci who designed the first floor. Following the fire of 1512, Bartolomeo and Guglielmo Grigi succeeded Coducci and added on the second storey, although the building was completed by Sansovino. The name «Procuratie Vecchie» (Old Magistrature) was given to distinguish the building from the «Procuratie Nuove» (New Magistrature) whose design is in keeping with the earlier building, so that the square an effect of stately harmony and balance. On the far side of the square, the side of San Geminiano, a very old church which Napoleon ordered torn down in 1807 so that a huge ballroom leading out of the royal palace (Palazzo Reale) could go up in its place, is the Ala Nuovissima (Most recent Wing) or the **Ala Napoleonica** (Napoleonic Wing). It is a neo-Classical design by Giuseppe Soli, who repeated the double orders of the Procuratie Nuove, adding a frieze of statues of Roman emperors and mythological and allegorical scenes to the top level. On the south side of the square is the **Procuratie Nuove**. Influenced by the Classical style of Sansovino's Library, Vincenzo Scamozzi designed it in 1584 and supervised the construction up to the tenth arch. The rest was once the residence of the *Procurators of St. Mark* but when the Republic fell in 1797 it was turned into the royal palace. Today it is occupied by cultural institutions such as the Correr and Archeological Museums.

THE CORRER MUSEUM

The Museo Civico Correr occupies the so-called Napoleonic or «Nuovissima» wing and the Procuratie Nuove in Piazza San Marco. It was founded in 1830 by a wealthy Venetian, Teodoro Correr, who bequeathed his fabulous art collection to his native city. The Museo Civico Correr includes three separate collections: History, Paintings, and the Italian Risorgimento Period. The History collection, on the second floor, contains fascinating relics of Venice's past, ranging from flags, portraits of doges, decrees, coins, maps, doges' robes, trophies, and various kinds of weapons. The first room also contains a famous statue, *Dedalus and Icarus*, a youthful marble group by Antonio Canova. The Painting Gallery occupies 19 rooms on the third floor with artists of the Venetian Byzantine school (especially the master responsible for the lid of the famous *Beata Giuliana dower-chest*), outstanding paintings by the renowned Bellini family, and two extraordinary *Pietàs*, one by Antonello da Messina and the other by Cosmè Tura. On the third floor, as well, is the **Museo del Risorgimento** (20 rooms), which contains mementoes of the Venetian role in the struggle for Italian unity.

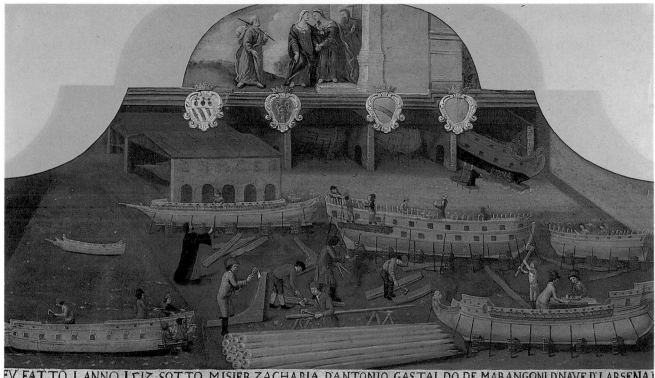

FV FATTO LANNO 1517 SOTTO MISIER ZACHARIA DANTONIO GASTALDO DE MARANGONI DNAVE DLARSENA
FV RINOVATO D LANNO 1753 SOTTO LA GASTALDIA DI FRANCESCO ZANOTTO GASTALDO ECOMPAGNI

View of a Venetian arsenal; below, from the left: *The Courtesans* by *V. Carpaccio* and *Portrait of the Doge G. Mocenigo* by *G. Bellini.*

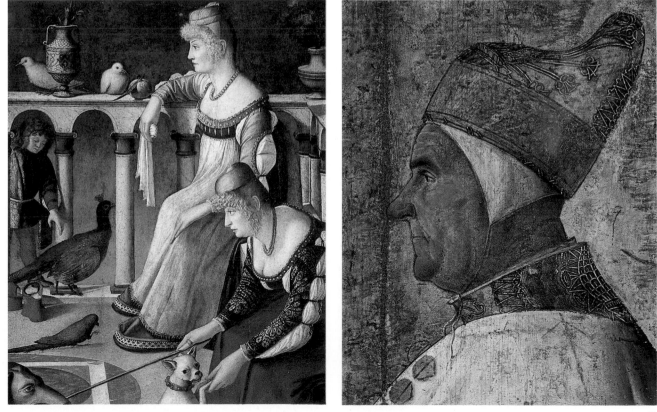

St. Mark's Basilica.

Opposite page: *aerial view of St. Mark's Square.*

ST. MARK'S BASILICA

It has been said that St. Mark's embodies the entire stream of the political, social, and religious history of the Republic of Venice. In 829 Doge Giustiniano Partecipazio commissioned the church as a fitting place in which to preserve the mortal remains of St. Mark the Evangelist who had become the sole patron saint of the city. The building was destroyed in a fire in 927 and rebuilt as we see it today between 1043 and 1071 by order of Doge Domenico Contarini. Originally the church was a combination of Byzantine (the Greek cross plan and domed covering) and Romanesque styles. Over the centuries its walls were covered with a glowing mantle of mosaics and precious marbles and its structure enhanced by architectural elements from the Orient. As a result, the basilica today is a harmonious blend of the Byzantine, Gothic, Renaissance, and Moorish styles.

The façade – Almost 52 meters long, the façade makes a most magnificent fourth side to the square. The protruding ground floor has five rounded arch portals supported by numerous columns noteworthy for their superb Oriental sculpted capitals. Although the central arch is larger than the others, all five are adorned with mosaics which we shall examine on the following pages. Between the arches are exquisite 12th century Byzantine bas-reliefs representing (from left to right): *Hercules and the Boar*, the *Virgin*, *St. George*, *St. Demetrius*, the *Archangel Gabriel*, and *Hercules and the Deer*. The whole first level is topped by a terrace set off by a railing. The second storey, with its mosaics and fanciful Gothic gargoyles, repeats the five-arch motif of the lower one. Here too the central arch is the largest, but instead of a mosaic it has glass panes which serve to light up the interior. The façade is

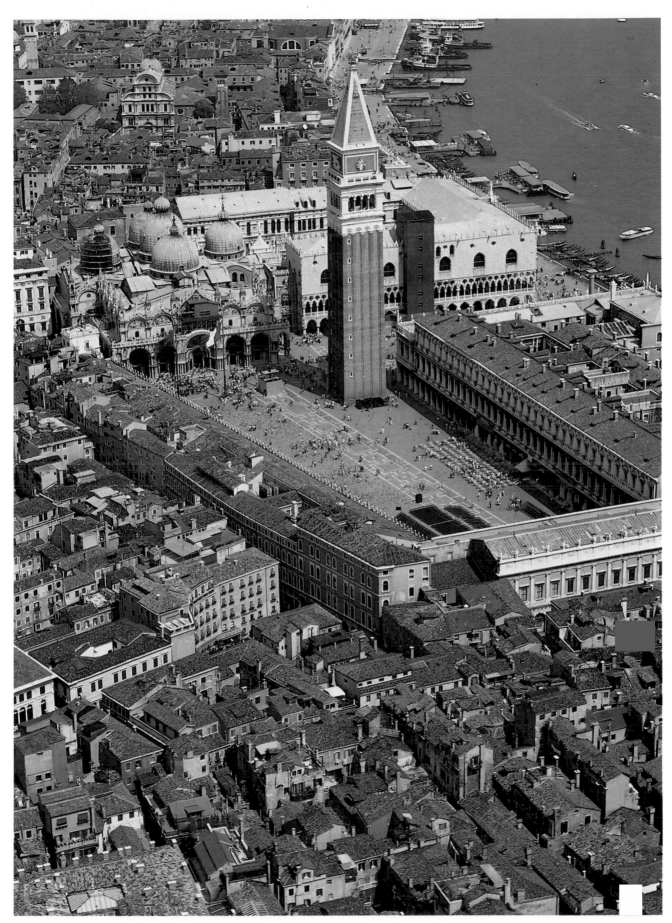

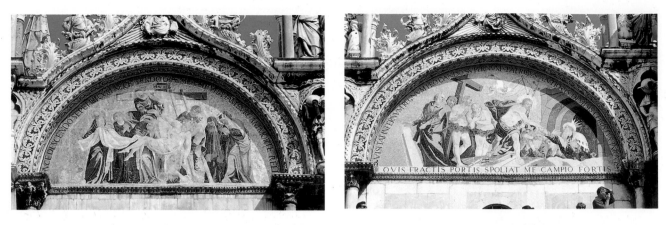

Deposition from the Cross and *Descent into Limbo*; below, from the left: *Resurrection* and *Ascension*.

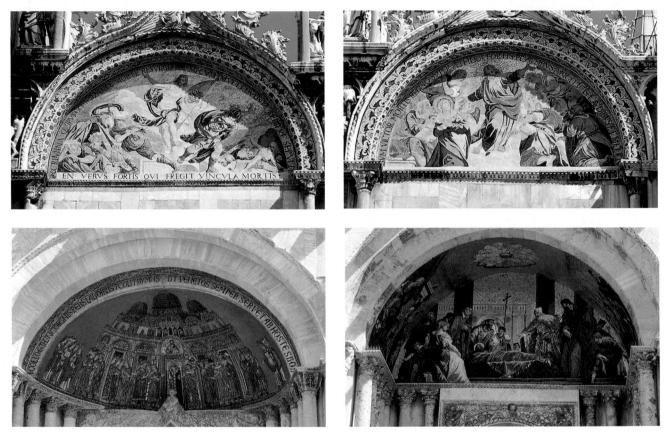

Transporting the Body of St. Mark to the Basilica and *The Venetians Pay Tribute to the Body of St. Mark*; below, from the left: *Arrival of St. Mark's Body in Venice* and *Removal of St. Mark's Body from Alexandria*.

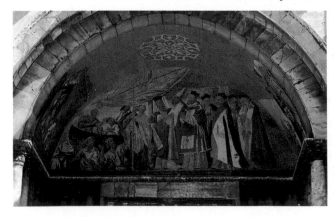
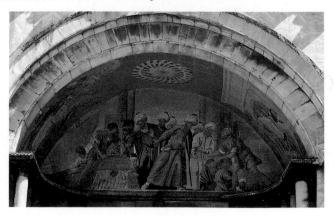

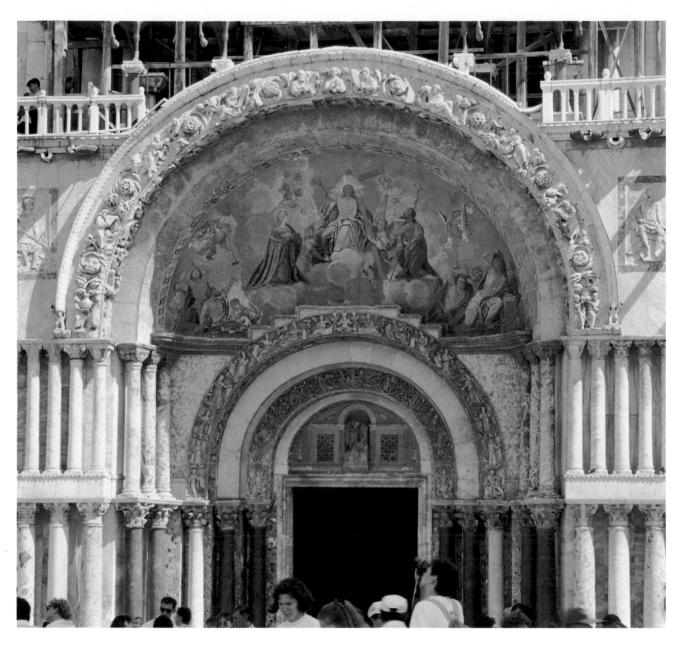

Central door of the basilica with the Last Judgement by L. Querena.

crowned by five round domes built in the 13th century and clearly influenced by Oriental prototypes. On the terrace above the main arch are the famous four **Greek horses** which have even been attributed to an artist of the stature of Lysippus. Once gilded, the bronze prancing steeds are masterpieces of 4th-3rd century B.C. Hellenistic sculpture. They were brought to Venice from Constantinople by Doge Enrico Dandolo in 1204 and stood on the terrace from 1250 until 1798 when Napoleon carted them off to Paris. The horses were returned to Venice in 1815. Although they were hidden away for the duration of both world wars, the statues suffered terrible damage from weathering over the centuries. Recently, however, they have been restored and replaced by copies. The originals are displayed in the Museum of the Basilica.

The atrium – From the main portal we enter the Atrium with its splendid mantle of golden mosaics. Its slightly pointed arches, the earliest of their kind in Italy, support six small domes. The floor is covered with mosaics (which create incredible effects of luminosity when the church is flooded, as it often is, in the cold season). The marble columns against the walls are of various origin, some are even said to have come from the Temple of Solomon in Jerusalem. The mosaics on the arches, lunette recesses, and domes illustrating scenes from both the Old and New Testaments, are all by expert 13th century Venetian craftsmen who expressed themselves in the lively narrative style of the Romanesque period illustrating *Episodes from the life of Noah* and the *Flood*. The emphasis on story-telling reaches its apex in the dramatic scene of the

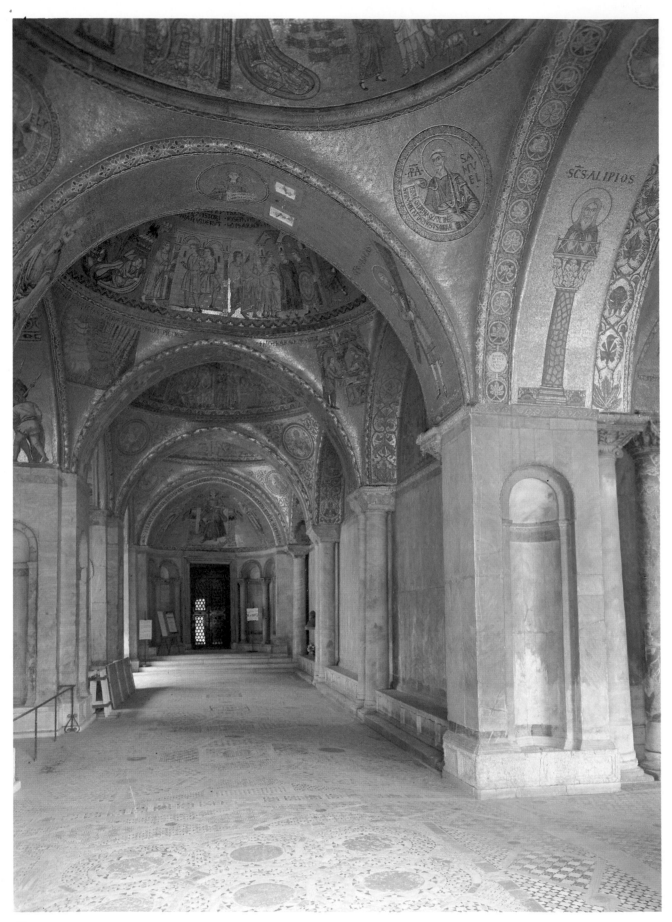

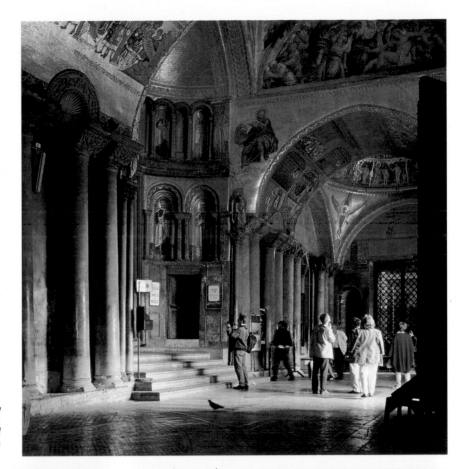

On this and the preceding page: *three views of the atrium of the Basilica*; below, right: *The Story of Noah and the Flood* (detail of the mosaics in the atrium).

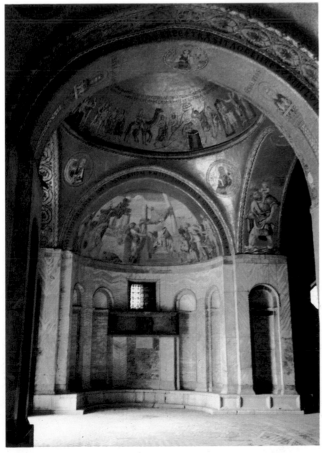

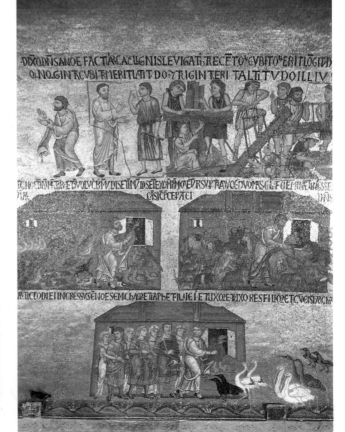

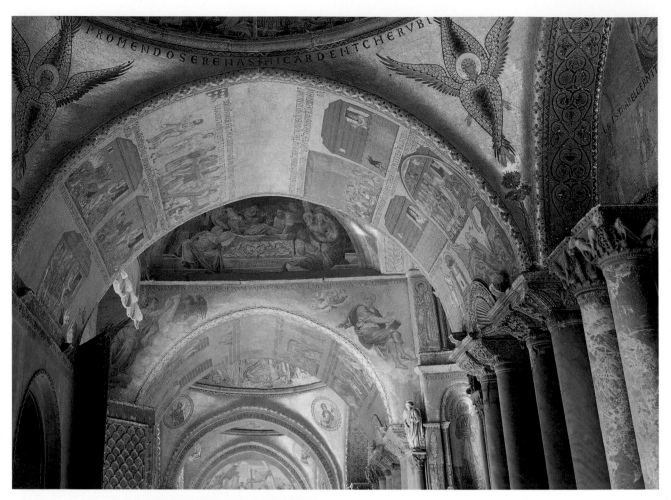

The arch of the Basilica's atrium, *splendid gallery with mosaics*; below: *scenes from the life of Moses.*

Facing page: *the Creation of the World.*

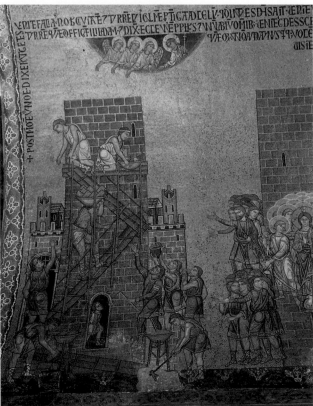

Flood with the half submerged bodies being dragged into the whirlpool. Outstanding for its fresh naturalism is the scene with the animals shown freely wandering in an airy landscape.

The interior – The plan of the church, is a Greek cross, with three aisles for each arm, separated from each other by round arches upon marble columns decorated with gilded capitals. Five huge domes sustained by massive pillars crown the whole. Above the two side aisles are the *matronei* (where the women sat), later turned into galleries after a 12th century fire damaged the interior. The railings of these galleries were built of material brought from the Orient. As was the Oriental custom, the choir is separated from the rest of the church by a rood screen. This consists of a coloured marble railing on top of which eight columns support an architrave with statues of the Virgin and the apostles. To the right of the rood screen is the *reliquary ambo* dating from the early 14th century. On the left, is the so-called *Double Ambo.* It is actually composed of two pulpits, one above the other: in the lower one the priest reads the Epistles, while the upper one is for reading the Gospels. The marble mosaic flooring is rather uneven due to the subsidence of the terrain on

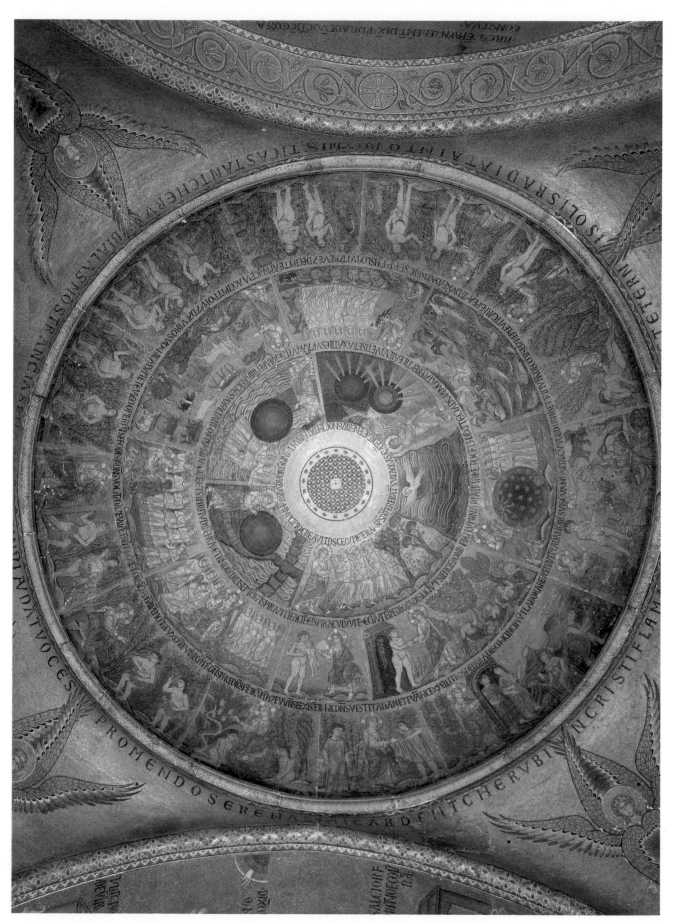

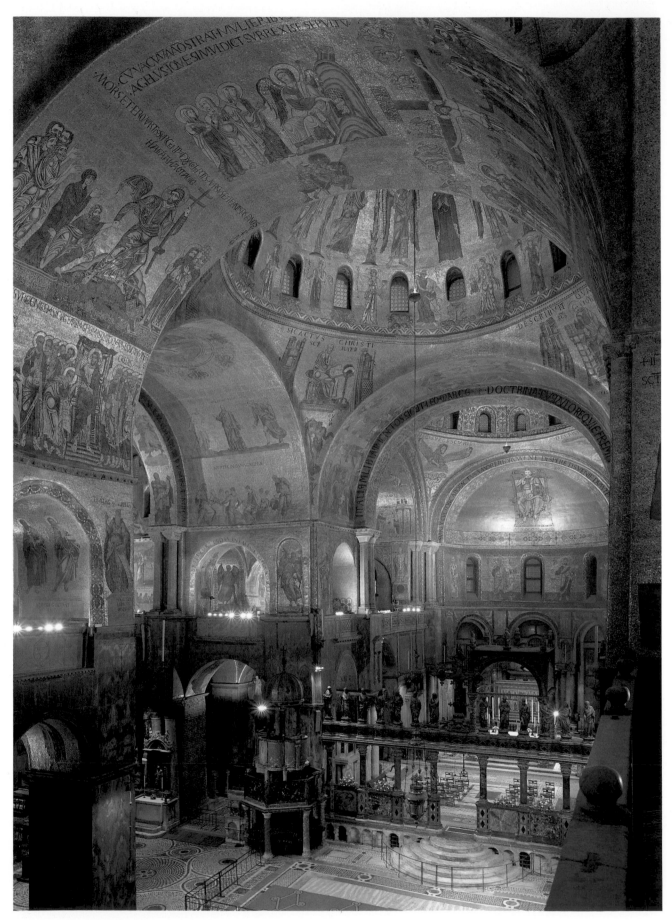

which the pylons supporting the building are anchored. Beneath the fourth arcade, is the *Capitello del Crocifisso*, a six-sided shrine with six marble columns surmounted by Byzantine capitals. Inside there is a panel painting showing a Crucifixion which probably came from Constantinople. According to a legend, it supposedly bled when someone attacked it with a knife. In one of the chapels of the left transept is the venerated image of the *Madonna Nicopeia*, a 10th century Byzantine panel which was brought to Venice after the Fourth Crusade of 1204. Noteworthy as well are the *St. Isidore* and *Mascoli Chapels* also in the left transept. The main altar houses the remains of the evangelist Mark in an urn behind the grating. Above the altar is a celebrated masterpiece of Medieval goldsmithing, the **Golden Altar Screen**. Its original nucleus dates back to 978 when Doge Pietro Orseolo commissioned it from artists in Constantinople. Doge Ordelaffo Faliero had it restructured in 1105 and then in 1209 it was further embellished by the addition of Byzantine gold and enamel pieces which were brought to Venice from the Monastery of the Pantocrator after the Fourth Crusade of 1204. All the Oriental material was recomposed in 1345 under Doge Andrea Dandolo by Giampaolo Boninsegna. The Screen, measuring 3,40 by 1,40 meters, (11 by 4½ feet) has eighty enamel plaques surrounded by a myriad of diamonds, emeralds, rubies, and topazes. The altar is divided into two levels; the lower one has a 12th century Byzantine enamel plaque depic-

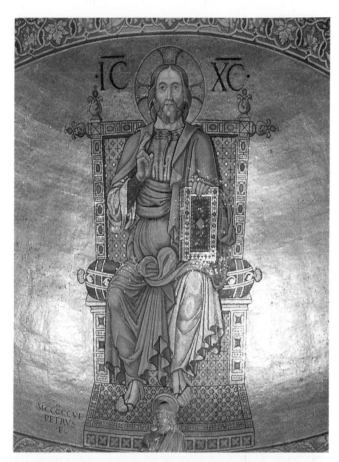

Preceding page: *the interior of Saint Mark's Basilica*.

Right: *Christ Enthroned Gives His Blessing* (apse); below: *a view of the women's gallery*.

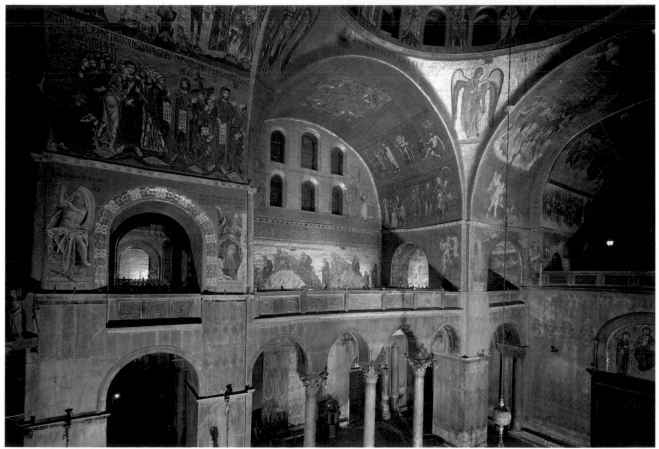

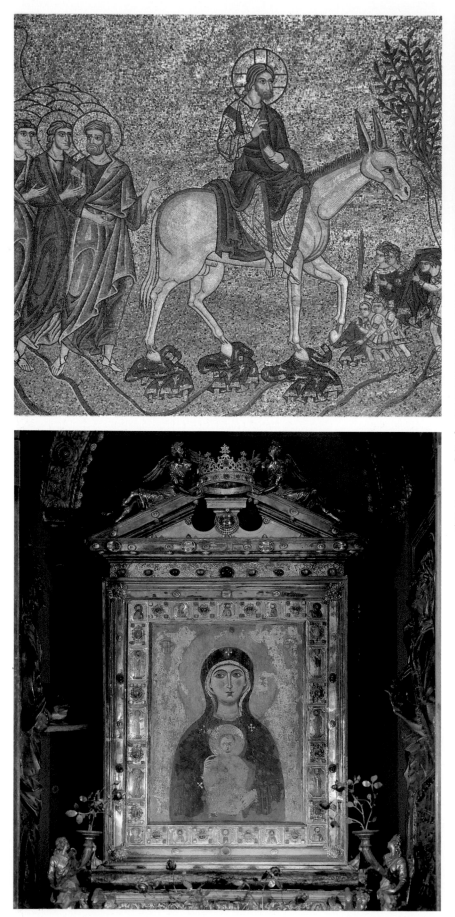

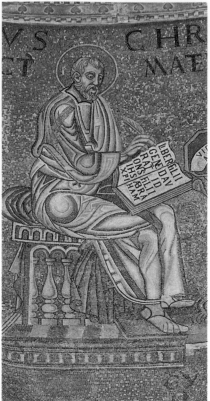

Top from the left: *Jesus Enters Jerusalem and Saint Mark the Evangelist*; opposite: *The Nicopeia Madonna, Byzantine panel, X century.*

Opposite page, top: *the Evangelists, St. John, St. Mark and St. Luke*; below, from the left: *the transept and left nave of the Basilica.*

On the following pages: *the golden altarpiece, a masterpiece of Medieval Venetian goldsmithing.*

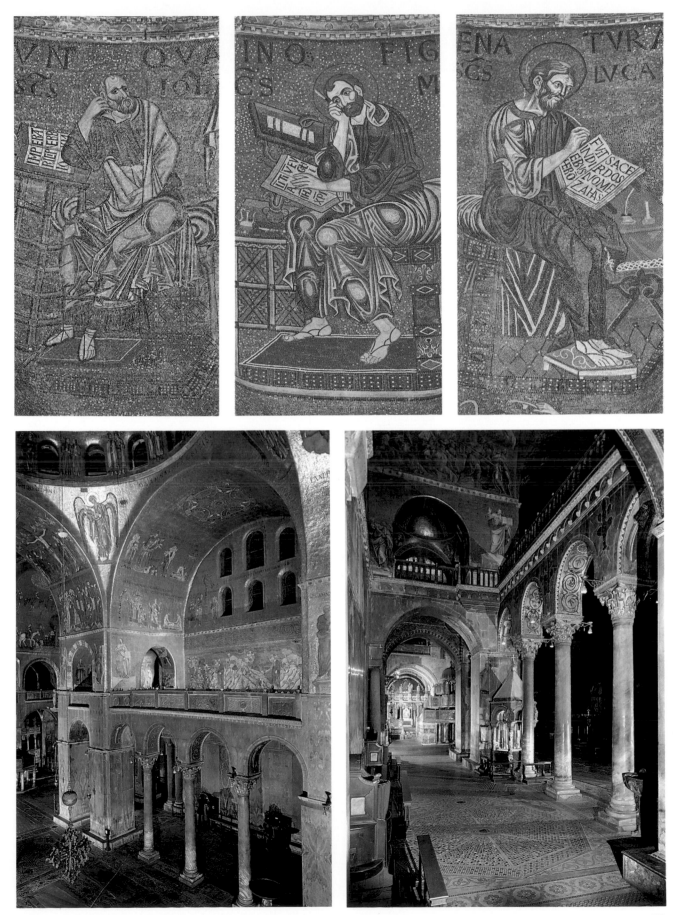

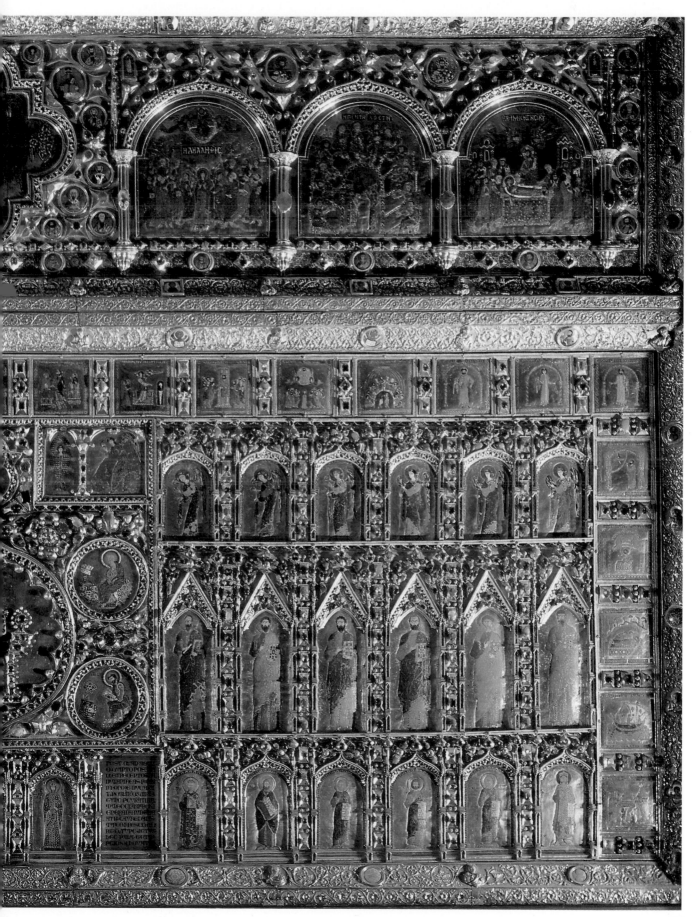

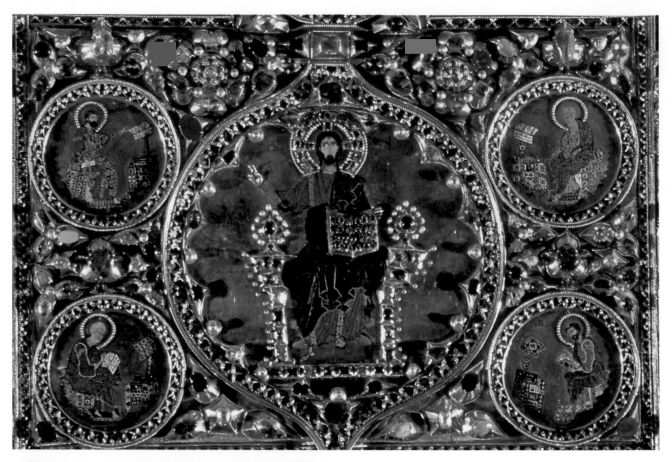

Center detail of the golden altarpiece; below: *detail of the floor inlays*.

ting *Christ Pantocrator* (The Almighty) surrounded by the four Evangelists in the center. The three registers of figures represent, from top to bottom, *Angels*, *Prophets*, and *Apostles* and *Saints*. The three figures just below the Christ show the *Virgin* flanked by the *Empress Irene* and *Emperor John Comnenus II*. The central panel of the upper level depicts the *Archangel Michael*, surrounded by saints an 11th-12th century Byzantine enamel. On either side are scenes from the New Testament (from left to right, they illustrate: *Christ Entering Jerusalem*, *Christ's Descent into Purgatory*, the *Crucifixion*, the *Ascension*, the *Pentecost* and the *Death of the Virgin*). The staircases by the Double Ambo lead to the crypt which has low cross-vaulted ceilings sustained by fifty marble columns. By the main altar through the Chapel of St. Peter is the Sacristy, a Renaissance structure designed by Giorgio Spavento. The **Museum of St. Mark**, on the same level as the galleries, is well worth a visit. It contains the *weekday altar-piece*, which is actually the Golden Screen's wooden case, painted by Paolo Veneziano in 1345. The **Treasury of St. Mark's** is of great interest. It contains a good part of the relics and precious objects collected during the Venetians' seafaring expeditions. Let us now examine the 4,000 meters of mosaic which cover every surface of the church above the columns and the marble wall plaques. All of the mosaics have gold grounds. Most date from the 12th-14th centuries, although some are of later date. All of them were laid by Venetian craftsmen of various

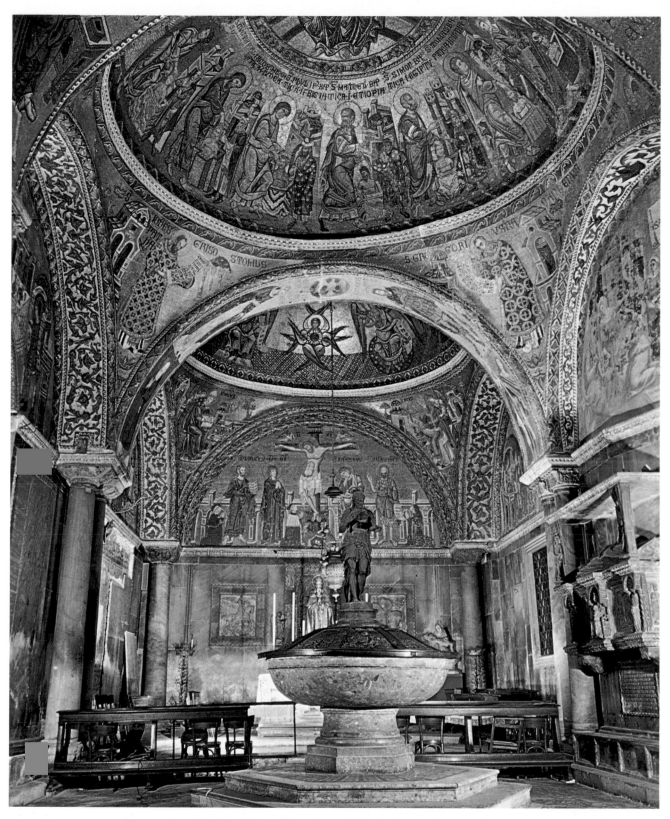

Interior of the baptistry and the statue of the baptist, by *Francesco Segala*.

periods with the contribution of great Renaissance masters from Tuscany. Art historians are inclined to believe that the mosaics were conceived as part of an iconographic treatise that came from the monastery of Mount-Athos.

The Baptistry – A bronze door in the right aisle leads into the baptistry. The huge *baptismal font* in the middle was designed by Jacopo Sansovino in the 16th century, although it was sculpted by Tiziano Minio, Desiderio da Firenze, and Francesco Segala (in the same century).

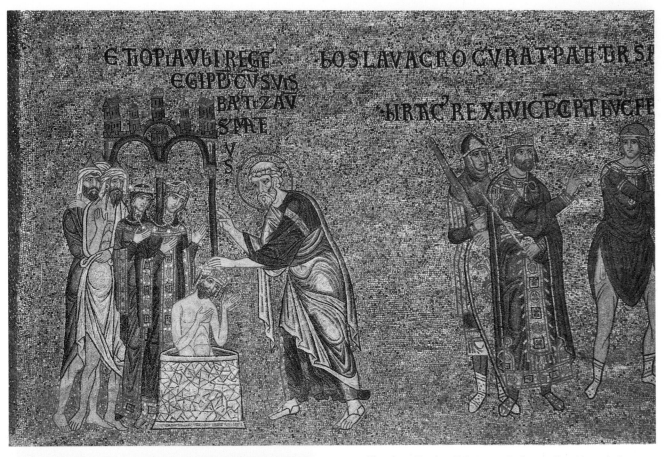

ε TIOPIΑ VΒΙ REGE
EGIPΒ CVSVS
ΒΑ Tι Ζ ΑV
SMΛΕ
VS

ΒΟS LΑVΑCRΟ CVRΑΤ PΑΒ ΒR SΙ

ΙRΑC REX Β VICΡ CΡΤ ΒVCΡΙ

The Apostles baptizing people from all nations; below:
St. Mark Writing (Zen Chapel).

+SCS MAC ROGAT AFRARIΒ; SC
EVΛΝGΙ

+CΙS ÑISI TΒFΑCÊT PΜΑRΕ ΒΙΝSCΡ
S MΛCΛΝGΙSΕ ΙΝSCΛSΙΤΨ POSTΛ

Segala also carved the *statue of St. John the Baptist*
surmounting the whole. Amidst the tombs of famous
doges to be found here is also that of Sansovino himself.
The Phoenician granite slab on which the altar table rests
is said to be one from which Christ once preached to his
disciples. The mosaics on the walls and ceiling were
created by Venetian artists in the 14th century. Their
subjects are the *lives of Christ and St. John the Baptist*.
There is a *Crucifixion* scene on the far wall, Christ sending
the Apostles to preach the Gospel, above the font, and all
around, on the register below, the *Apostles baptizing
people from all over the world*. In the pendentives are the
Four Doctors of the Greek Church. The dome above the
altar has a mosaic of *Christ in Glory* with the *Four Doctors
of the Roman Church* in the pendentives. The baptistry
leads to the **Zen Chapel**, i.e. the funerary chapel of
Cardinal Giovan Battista Zen. It too once looked out on
the Piazzetta, until it was given its present appearance
by Antonio Lombardo and Paolo Savin in 1521. Upon the
altar is the celebrated image known as the *Virgin of the
Shoe* since a shoe, offered by a worshipper, miraculously
turned into solid gold. In the middle of the chapel is the
bronze tomb of Cardinal Zen. The walls are covered with
13th century mosaics, still remarkable, despite much
restoration. Of particular note is the apse mosaic which
depicts the *Virgin and Child with Angels*. Flanking the
altar is a pair of marble lions from the school of Benedetto
Antelami, the great Romanesque sculptor from Parma.

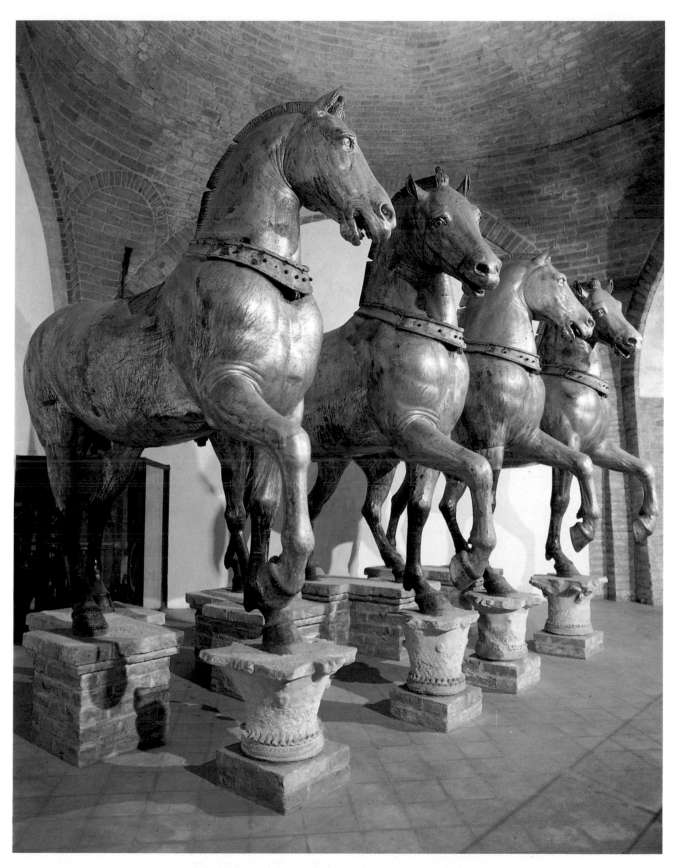

The famous horses of St. Mark's Basilica after restoration.

The Acre Pillars and *The Tetrarchs*.

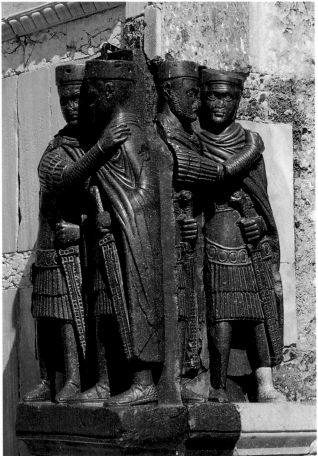

THE ACRE PILLARS
THE TETRARCHS

On the Doges' Palace side of St. Mark's Basilica, there are two squarish pillars of Syrian provenance, called the **Acre Pillars**, brought to Venice in 1256, after a victory against Genoa. The porphyry group of **Tetrarchs** on the corner of the Basilica, is also Syrian and supposedly portrays the four Roman Emperors Diocletian, Maximian, Galerius and Constantius, holding each other in a tight embrace, to symbolize the unity of the Empire.

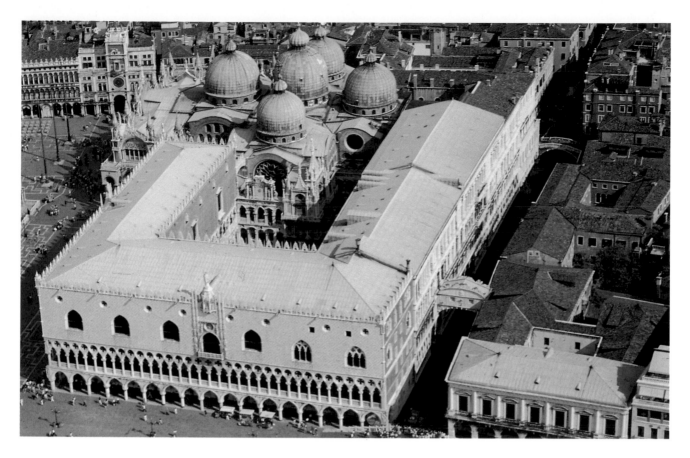

Aerial view of the Doges' Palace.

On the two following pages: *the façade of the Doges' Palace.*

THE DOGES' PALACE

The name of the architect who designed this remarkable building has not come down to us but, whoever it was, made it the symbol of the supreme glory and power of the «Repubblica di San Marco». It was on this site that, towards the end of the 9th century, Doges Angelo and Giustiano Partecipazio established the seat of the government which came to be known as the «Palazzo Ducale» (Doges' Palace), since it was the residence of the Doge, the supreme head of state. The impressive structure we see today looks nothing like its original nucleus. We only know that the Byzantine palace built over pre-existing Roman walls, was burnt down in the 10th century. Thereafter it was rebuilt a number of times. The last time being in 1340. An uncertain tradition ascribes the building of the 14th century palace to Filippo Calendario, stonecutter, Pietro Baseio, and Master Enrico. The façade overlooking the lagoon was completed between 1400-1404, whereas the Piazzetta side was not ready until 1424. Although renowned masters from Florence and Lombardy were called in to take part in the decoration of such a prestigious building, most of the ornamental design in the elaborate style known as Flamboyant Gothic, was handled by a Venetian family of highly skilled marble carvers, the Bon family. Then in 1577 another fire broke out, burning down an entire wing. Another competition for its reconstruction was announced and entries from the most celebrated architects of the day poured in.

Had the great Palladio won, a classical style building would undoubtedly stand in its place today, but the commission was instead awarded to Antonio Da Ponte, the architect of the Rialto Bridge, who restored the original appearance of the palace. A person approaching it from the canal perceives it like a fairytale mirage with its delicate pink and white patterned walls and its seemingly weightless architectural structure. The façade is symmetrically broken up by the lovely carved balcony built by Pier Paolo and Jacobello Dalle Masegne in 1404 in true Flamboyant Gothic style, that is with elaborate sculptural decoration, Rising above the whole is a statue of Venice in the guise of Justice, a 16th century work by Alessandro Vittoria. Worthy of attention amongst the elegant carved capitals of the arcade columns is the first one on the Piazzetta side representing Adam and Eve in the Earthly Paradise (early 15th century). The west façade over looking the Piazzetta closely resembles the south side with a balcony built by pupils of Sansovino in 1536 imitating the one designed by the Dalle Masegnes. Over the pointed arch window is a panel with Doge Andrea Gritti before the symbol of Venice, a modern work by Ugo Bottasso, and, on the very top, a statue of Justice by Alessandro Vittoria. In October 1866 the annexation of Venice to the kingdom of Italy was proclaimed from this balcony (after various vicissitudes had caused the Doges' Palace to be first used as headquarters for the Austrian government

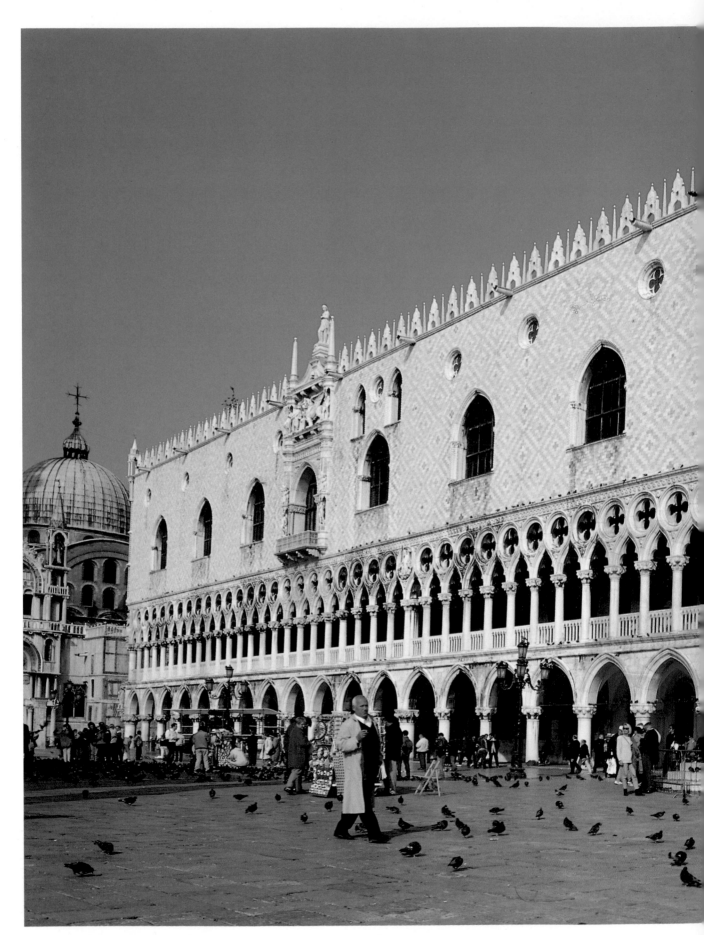

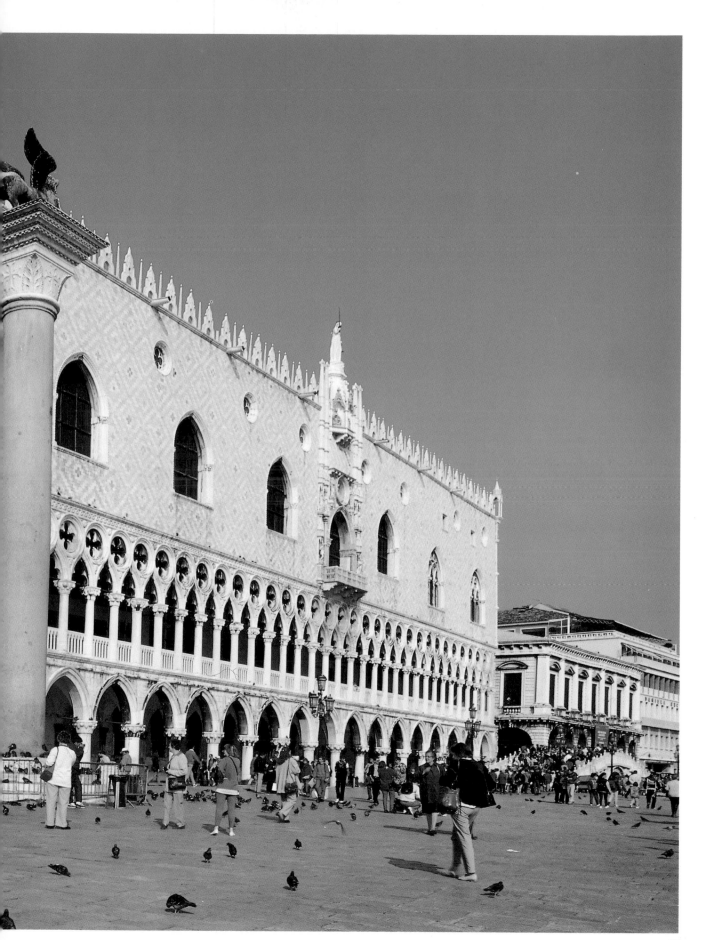

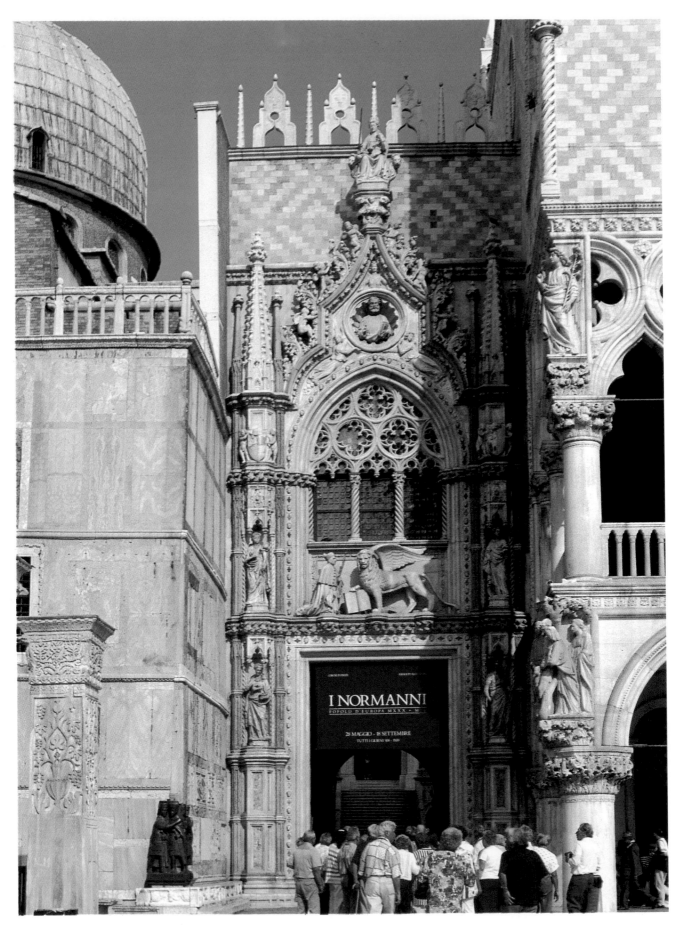

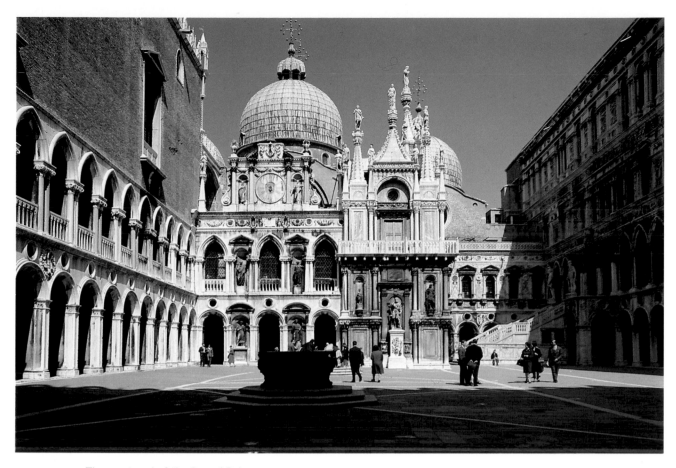

The courtyard of the Doges' Palace.

Proceding page: *the Porta della Carta, surmounted by the statue of the Doge Francesco Foscari before the winged lion.*

THE COURTYARD OF THE DOGES' PALACE

and the as temporary quarters for the Marciana Library). The palace also served as the meeting place for Daniele Manin's democratic government between 1848 and 1849. The damage caused by the popular uprising of 1797, when the Republic fell, was soon repaired and today the building has returned to its antique splendor replete with the art treasures that the various doges and heads of state had collected over the centuries to adorn the halls where decisions regarding the city were made.

On the lefthand side of the Doges' Palace façade over the Piazzetta is the so-called **Porta della Carta**, literally, Charter Portal, to which government decrees were affixed. The upper part, elaborately carved as befits the Gothic taste, is the work of the Bon family. Just above the door-way is a statue of *Doge Francesco Foscari kneeling before the Winged Lion* (modern) while the seated woman above the tallest spire represents *Justice*. On the corner of the doges' Palace is a famous sculptural group depicting the *Judgment of Solomon*. This extraordinary 15th century sculpture has been attributed to either Pietro Lamberti or Nanni di Bartolo.

The Porta della Carta leads into the **Foscari Arcade** which we cross to enter the courtyard of the Doges' Palace. Its effect is both quiet and majestic. In the middle is a pair of imposing bronze *well basins*. The one closer to the door is by Alfonso Alberghetti (1559), while the other is by Niccolò dei Conti (1556), both of whom worked as cannon forgers for the Republic of St. Mark. The main or eastern façade (facing the entrance) was designed by Antonio Rizzo at the end of the 15th century. The elaborate decorative scheme is by Pietro Lombardo (15th century). The right side was designed by Scarpagnino in the mid 1500s, whereas the two brick façades which border the courtyard on the south and west sides were built by Bartolomeo Manopola in the 17th century to recall the outer façades. The arches of the north façade, on top of which is a huge clock, are broken up by niches with restored antique statues another Baroque creation by Manopola. To the right, set on a tall base, is a *monument to Francesco Maria I della Rovere* sculpted by Giovanni Bandini in 1587. By the Staircase of the Giants is the *Foscari Arcade*, begun by the Bons in the Gothic style and later finished by Rizzo and the Bregnos according to Renaissance taste. Along the top of the structure are statues of St. Mark and other allegorical figures. The niches below contain statues of *Adam and Eve*, bronze copies of Antonio Rizzo's originals, now inside the palace. Alongside the Staircase of the Giants is the tiny Courtyard of the Senators where the senators of the Republic supposedly gathered during official ceremonies. The

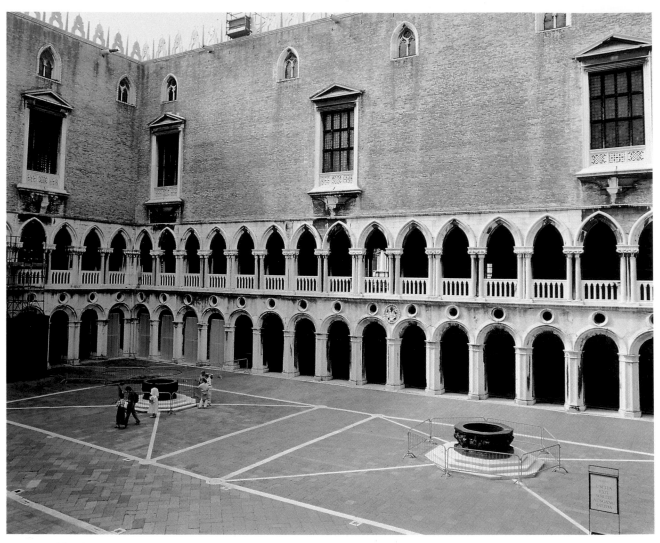

The Renaissance wing of the courtyard, below: *two bronze well-heads*, *Niccolò dei Conti* (left) and Alfonso Alberghetti (right).

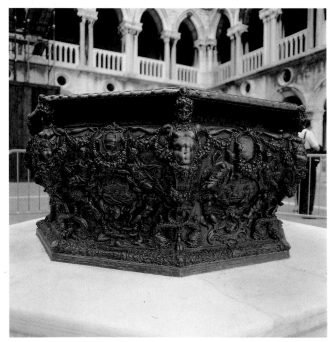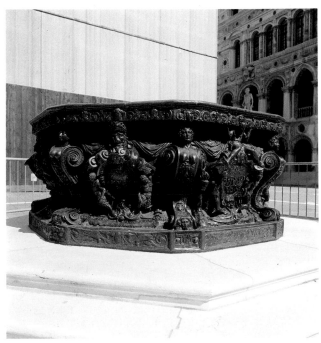

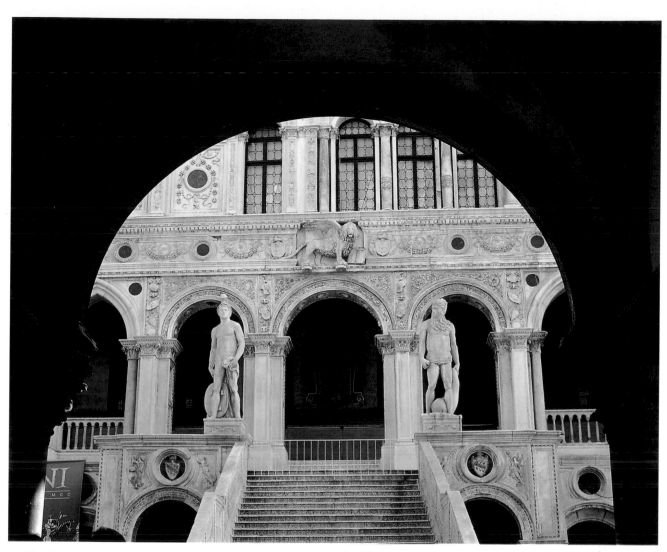

The Staircase of the Giants; below: *the statues of Mars and Neptune, by Sansovino.*

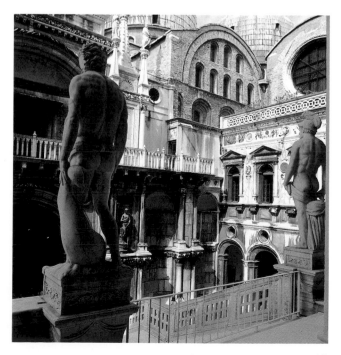

Staircase of the Giants received its name from the two huge statues of *Mars* and *Neptune* on the landing. The statues are by Sansovino and his pupils; the overall plans, however, were designed by Antonio Rizzo at the end of the 15th century. The new doges were officially crowned on the landing at the top of the staircase. Along the loggias and inside the palace, one comes across the carved stone «*Lions' Mouths*», which used to be the receptacles of the secret informers' denunciations and reports to various public officals. The plaque which commemorates Henry IIIrd of France's 1574 visit to Venice, by Alessandro Vittoria, in the loggia, near the Giant's Staircase, is also much admired. The other plaque inscribed in Gothic lettering reminds the faithful of the indulgences granted to anyone praying for the prisoners in the nearby Chapel of St. Nicholas, dated 1362. Further on, a great classical archway, with two protruding marble columns bearing *Hercules slaying the Hydra* and *Atlas carrying the Earth*, by Tiziano Aspetti, leads to the golden staircase. The arms of Doge Andrea Gritti (1523-1538), who commissioned the staircase, are set into the keystone of the Arch.

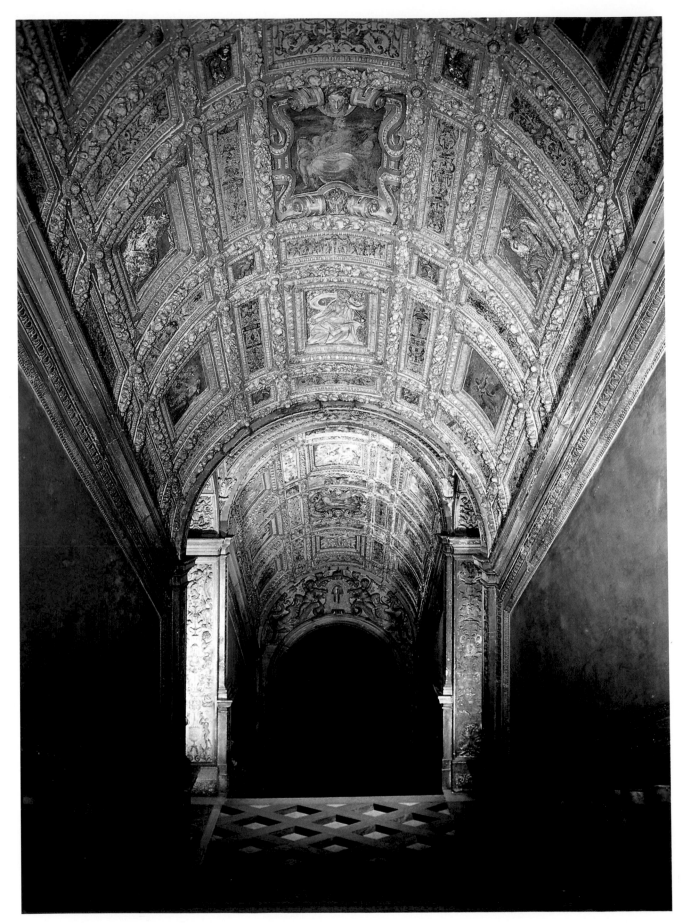

THE INTERIOR OF THE DOGES' PALACE

Above: *Sala degli Scarlatti*; below: *Room of the Maps, or of the Coat of Arms.*

Preceding page: *the Golden Staircase.*

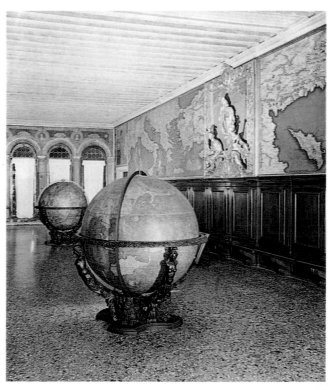

To reach the upper floors of the Palace, we take the **Scala d'Oro**, literally, the Golden Staircase, designed by Sansovino in 1538 for Doge Andrea Gritti, but completed by Scarpagnino in 1559. The staircase, with a barrel vault ceiling covered with splendid gilded stucco reliefs, was originally reserved for the VIPs of the day. The first arch at the entrance is decorated with two sculptures by Tiziano Aspetti (2nd half of the 16th century) portraying *Hercules* and *Atlas*. Two statues by Francesco Segala symbolizing *Abundance* and *Charity* decorate the third floor. The second floor served as the doges' private apartments. The first doge to occupy them was Agostino Barbarigo towards the end of the 15th century, as they were built by Antonio Rizzo and Pietro Lombardo after the 1483 fire. We enter the **Sala degli Scarlatti** in which all the dignitaries, wearing their scarlet colored robes, gathered to wait for the doge who was to preside during official ceremonies. The magnificent decoration was carried out under the supervision of Pietro Lombardo. Noteworthy are the two reliefs above the doorways which depict *Doge Leonardo Loredan at the feet of the Virgin and Saints* by Pietro Lombardo and a *Virgin and Child* from the 15th century Paduan school. We then enter the **Room** of the **Maps** (or **Coat-of Arms**) which served as the antechamber to the doges' apartments. The coat-of-arms of the reigning doge was displayed here. The name «Map Room» derives from the fascinating maps by Giovan Battista Ramnusio (1540) Francesco Grisellini and Giustino Menescardi (1762) that decorate the walls. Two huge 18th century globes stand in the center of the room. The

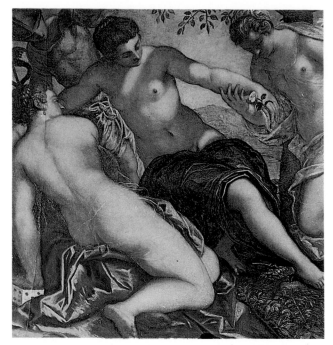

Mercury and the Three Graces, by *Jacopo Tintoretto* (Sala dell'Anticollegio).

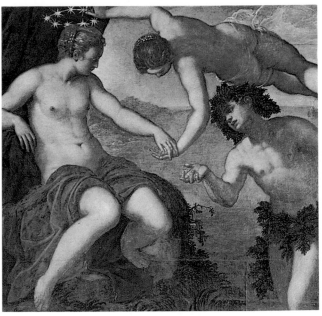

Vulcan's Forge, by *Jacopo Tintoretto* (Sala dell'Anticollegio).

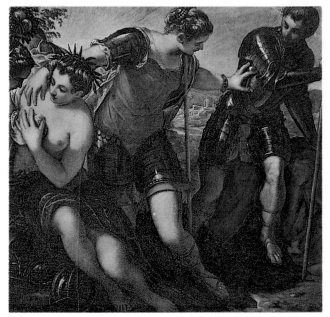

Minerva Dismissing Mars, by *Jacopo Tintoretto* (Sala dell'Anticollegio).

Ariadne, Bacchus and Venus, by *Jacopo Tintoretto* (Sala dell'Anticollegio).

Facing page: *Sala del Collegio.*

Grimani Hall was where the doge received dignitaries. In the center of the elaborate gilded and carved wooden ceiling (early 16th century) is the coat-of-arms of the Grimani family, after whom the hall was named. The painted frieze below the ceiling has been attributed to Andrea Vicentino. Above the elegant Lombard-style fireplace is a later Baroque addition commissioned by Pasquale Cicogna. The **Erizzo Hall** also contains a Lombard-style fireplace and has a decorative scheme resembling those of the rooms we have just seen. The **Stucco** (or **Priuli**) **Hall** gets its name from the ceiling stucco decoration and the coat-of-arms belonging to Doge Lorenzo Priuli (mid 15th century) which appears on the fireplace and door jambs.

The stucco decoration (note the unusual caryatid figures) was commissioned at the end of the 16th century by Doge Marino Grimani. In the center of the ceiling is the coat-of-arms of Doge Pietro Grimani who had the project completed around the middle of the 18th century. Fine stucco frames surround equally fine paintings: *Henry III of France*, a copy of a Tintoretto; the *Adoration of the Shepherds*, by Leandro da Ponte known as Leandro Bassano; the *Adoration of the Magi*, by Bonifacio de' Pitati; *Holy Family*, by Salviati, and *Dead Christ Supported by Angels*, by Pordenone. From here we reach the **Hall of the Philosophers**, actually a long passageway named after the twelve paintings depicting philosophers created by Vero-

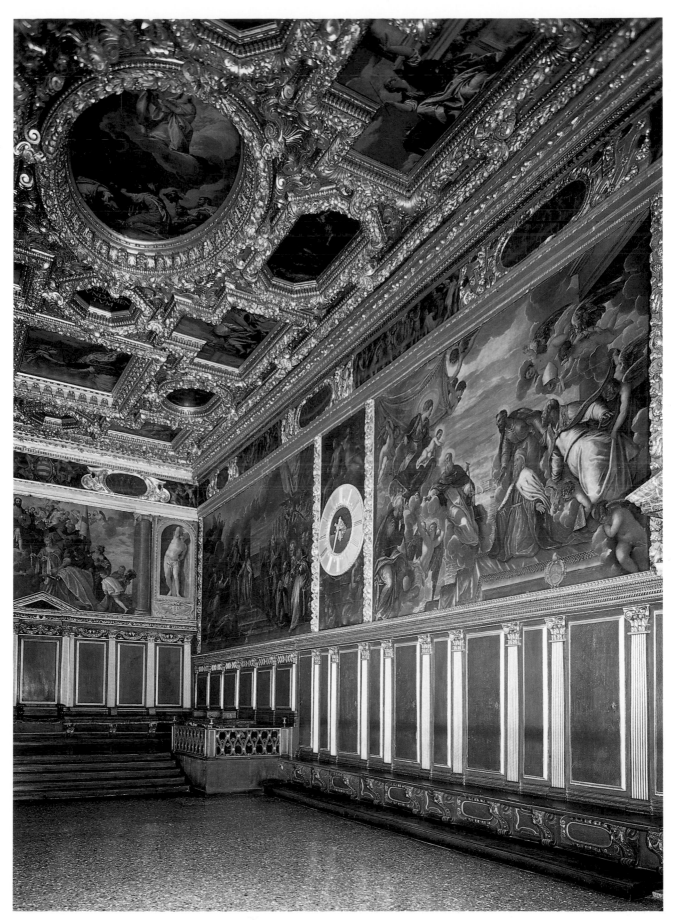

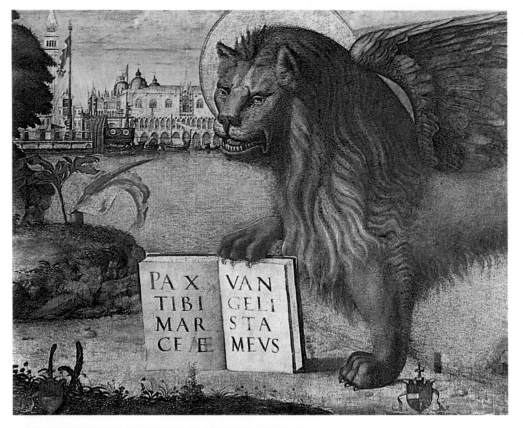

nese, Tintoretto, and others for the Marciana Library. The stucco wall decoration was commissioned by Doge Marco Foscarini in the 18th century. Doge Andrea Gritti commissioned Titian's *St. Christopher*, painted in 1524, which adorns the door of the chapel next to the hall. The Hall of the Philosophers leads to three rooms known as the **Pinacoteca** (Painting Gallery). These rooms, once belonging to the doges' private suite, overlook the little canal behind the Doges' Palace. Noteworthy are the 15th century fireplaces with the Barbarigo coat-of-arms, covered with elaborate decorations. In the rooms are paintings once hung elsewhere in the palace. The first one contains a *Lamentation* by Giovanni Bellini and facing it, Carpaccio's famous *Lion of St. Mark* painted in 1516. In the second room are paintings by the famous 16th century painter Bosch. The two panel paintings represent *Heaven* and *Hell*, while the subjects of the two altarpieces are the *Temptation of Sts. Jerome, Anthony, and Egidius*, and the *Martyrdom of St. Juliana*. These paintings, called «stregozzi» (literally, spellbinders in Italian) are typical products of Bosch's striking imaginative genius. In the third room is a sweet *Virgin and Child* by Boccaccino. From the **Square Atrium**, its gilded wooden ceiling adorned with a painting by Jacopo Tintoretto, we proceed to the **Room of the Four Doors**, designed by Andrea Palladio, and named for the monumental doors at each end. The hall contains elaborate stucco decorations by Bombarda and paintings by Tintoretto. One of the master's best-known works, *Doge Antonio Grimani Kneeling Before Faith*, is above the entranceway. In the **Sala dell'Anticollegio** (ante-chamber), ambassadors and other highranking figures would wait before being received by the College of the Republic. The walls are hung with outstanding works by Jacopo Tintoretto, among which are *Mercury and the Three Graces, Bacchus and Ariadne*, and *Minerva Dismissing Mars*.

We now enter the **Sala del Collegio** which was where the

Doge Pasquale Cicogna Assisted by St. Mark Praying to Christ, by *Palma the Younger* (Sala del Senato).
On the next two pages: *Sala del Senato*.

council composed of the Doge, his six advisors, other councillors, and the Grand Chancellor held their meetings. Here the most important decisions relating to the government of the Republic were discussed. The hall was designed by Antonio Da Ponte in 1574 after another of the numerous fires had destroyed a previously existing one. The superb gilded stuccos on the ceiling, by Francesco Bello, are exquisite frames for the allegorical paintings by Paolo Veronese (outstanding is the *Venus Enthroned Being Adorned by Peace and Justice*, above the tribune). Perhaps the finest of the wall murals is Tintoretto's *Marriage of St. Catherine before Doge Francesco Donà in Prayer, and Saints*. Paolo Veronese's *Sebastian Venier*

Giving Thanks to the Saviour for the Victory at the Battle of Lepanto decorates the wall behind the throne. From here we go to the **Sala del Senato** also known as the Hall of the Pregadi (senators). It too was rebuilt by Antonio Da Ponte and was where the Senators met. The elaborate ceiling was designed by Cristoforo Sorte of Verona. The room is hung with fine paintings, among which are Tintoretto's *Dead Christ with Angels Adored by Doges Pietro Lando and Marcantonio Trevisan*, over the tribune, the *Allegory of the Cambrai League* by Palma; *Doge Pietro Loredan Beseeches the Virgin to End the Famine*, by Tintoretto, and *Doge Pasquale Cicogna Assisted by St. Mark Praying to Christ*, by Palma the Younger. From the

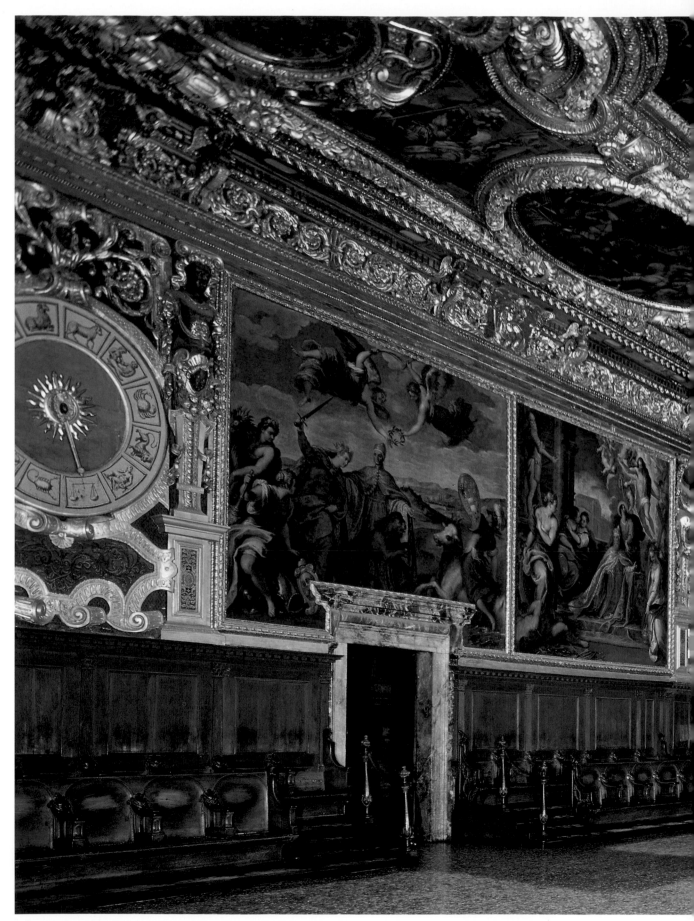

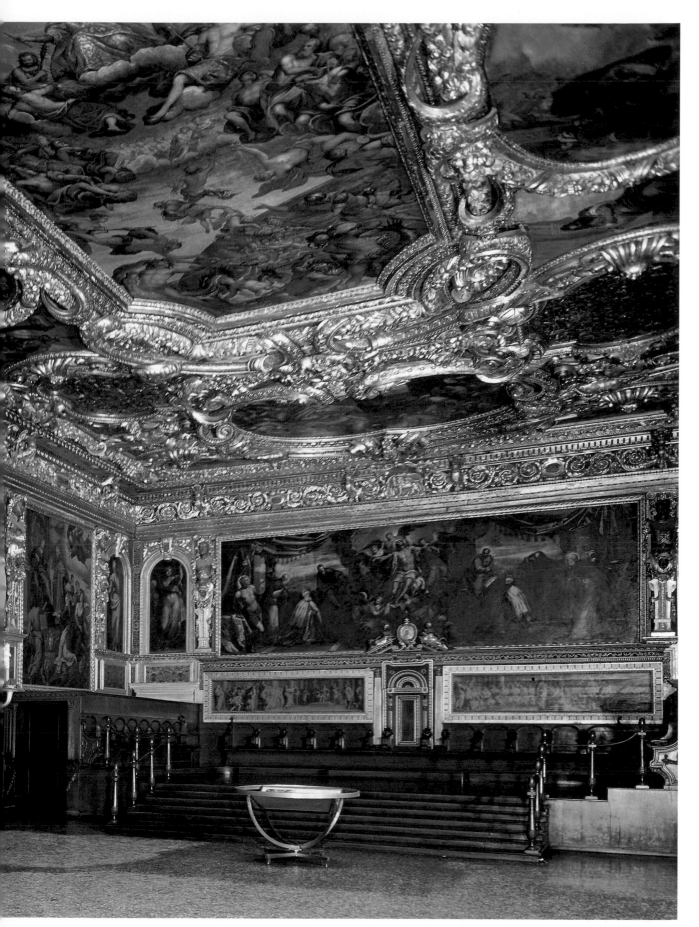

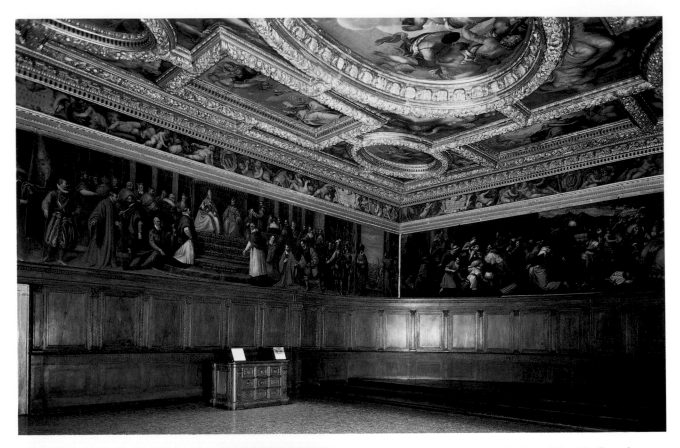

Sala del Consiglio dei Dieci, below: *Sala della Bussola*
Opposite page: *Sala dei Tre Capi*.

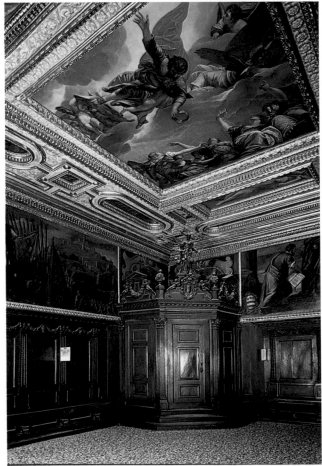

Hall of Senate we enter the **antechamber** of the church and then the **church** itself which contains a fine *Virgin and Child* by Sansovino. The **Sala del Consiglio dei Dieci** (Hall of the Council of Ten) was the seat of the tribunal which judged crimes against the state. The doge presided over the council which was composed of ten members belonging to the Greater Council and six councillors. Above this room were the notorious «piombi», or prison cells with lead (piombo) ceilings. Casanova, Giordano Bruno, Silvio Pellico, Daniele Manin, and Niccolò Tommaseo, famous Italians, were all «guests» of the piombi in various periods. The ceiling of the Sala del Consiglio dei Dieci, 1554, like the others in the Doges' Palace is an elegant and elaborate frame for noteworthy works of art. Originally there was a masterpiece by Veronese, *Jupiter Smiting Vices* in the center, but it was carried off by the French in 1797 and is still in the Louvre. A copy by Jacopo di Andrea is in its place. The four ceiling panels portray *Mercury and Peace* by Ponchino, *Juno Pouring Treasures on Venice* by Veronese (this one too carried off to France in 1797, but returned by Belgium in 1920), and *Venice Breaking her Chains* and *Venice Between Mars and Neptune*, by Giovan Battista Zelotti. In the oval panels, *Neptune in his Chariot* by Ponchino, *Old Man in Eastern Dress and Young Girl* by Veronese, and lastly, *Venice Over the Globe and the Lion of St. Mark* by Zelotti. The frieze bordering the ceiling is adorned with cupids and coats-of-arms. Beneath the frieze there are three large paintings showing the *Meeting of Charles V and Pope Clement VII in Bologna* by Marco Vecellio, *Pope Alexander II Blessing Doge Sebastiano Ziani* by Francesco and Leandro Bassano and an *Adoration of the Magi* by Aliense. We then enter the **Sala della**

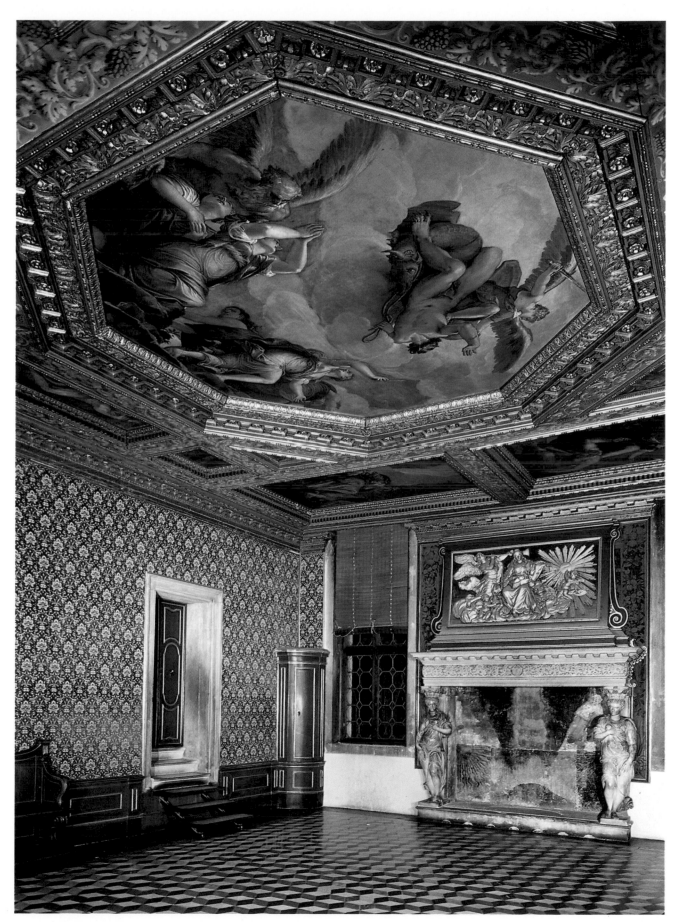

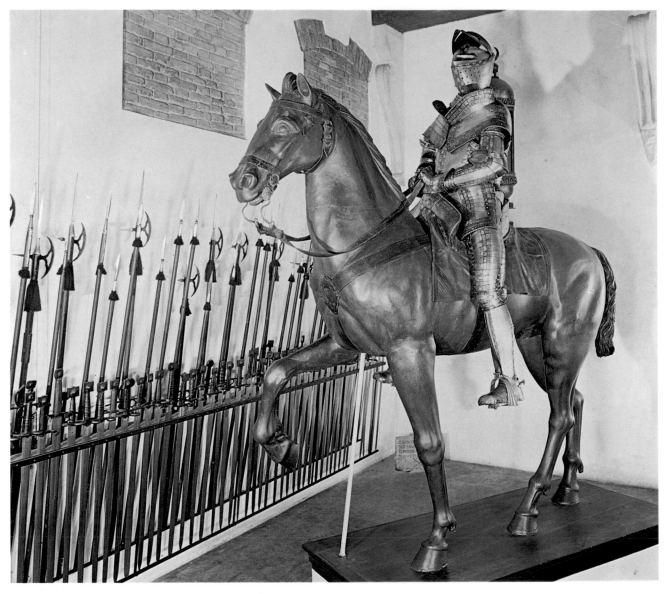

Gattamelata's equestrian armor.

Bussola (Room of the Booth) which served as the antechamber for the preceding room. The booth which gives the room its name is in a corner of the room dubbed «bussola» (booth) by the Venetians. Along the walls you can still see the so-called *bocche di leone* (literally, lions' mouths) which are actually slots where the local citizens could drop anonymous denunciations and which you will find elsewhere in Venice. From the Bussola vestibule we enter the **Sala dei Tre Capi del Consiglio dei Dieci** (Room of the Three Heads of the Council of Ten). These men were entrusted with the security of the Republic and preventing espionage. They were also called State Inquisitors. Once, down a little staircase from this room, one could reach the «piombi» and the torture chamber. The ceiling is divided into five sections. In the octagonal panel in the middle is an allegory, the *Victory of Virtue over Vice*, by Giovan Battista Zelotti; in the other panels surrounding it are the *Punishment of a Forger*, *Sin Vanquished by Victory*, both by Veronese; *Rebellion Vanquished by Justice* and *Sacrilege Flung Down a Precipice* by Ponchino. In this room too between the windows there is a fireplace, greatly resembling the one in the Sala della Bussola, with

a pair of female caryatid figures by Cattaneo and Grazioli. You enter the *Room of the Three State Inquisitors* through a door to the left of the window. On the ceiling of this room is a painting by Jacopo Tintoretto depicting the *Return of the Prodigal Son and Four Personifications of Virtues*. Returning to the Sala della Bussola we reach the landing of the Scala dei Censori which we cross to enter the **Armoury of the Council of Ten** (this will be discussed in greater detail on the following pages) which assembles an immense variety of interesting weapons. This collection of 15th and 16th century pieces is truly unique, as it is made up of weapons really used to defend the palace, and not the usual museum hodgepodge of pieces randomly acquired here and there. By 1317 the Doges' Palace already had its own armoury, but then in 1532 this room was selected as the new arsenal. Although numerous pieces were dispersed, especially during the French looting of 1797, the collection presently totals about 2000 objects. In the first room called the *Weapons or Gattamelata Room* is the *armour* supposedly worn by the celebrated condottiere (captain) of the Republic, Erasmo Gattamelata. One of the most unusual exhibits is a rare helmet

shaped like a birdbeak known as «Attila's visor». There is also a fine *bust of Doge Sebastiano Venier* by Vittoria. In the second room called the **Hall of Henry IV** we can admire a *suit of armour* belonging to king Henry of France. In the middle is a superb artistically decorated culverin. There is also a *boy's suit of armour* dating from the 16th century. The third room: the **Morosini Hall** received its name from the bronze *bust of Francesco Morosini*, the heroic Venetian admiral. The walls are covered with rows of halberds, pikes, and spears of every kind.

Going down the **Scala dei Censori** leads us back to the second floor where we have already the wing with the doge's private apartments. We shall now visit the area reserved for the Maggior Consiglio. First, we enter the **Sala della Quarantia Civil Vecchia**, in which a council of forty nobles met. The adjoining room, called the **Guariento Hall**, contains what is left of a magnificent fresco depicting *Paradise* painted by Guariento between 1365 and 1367 for the Sala del Maggior Consiglio and destroyed in a fire in 1577. A *Coronation of the Virgin* and some *figures of Saints, Angels,* and *Prophets* are the only surviving parts. Now back in the corridor we can proceed to the largest room in the whole palace, the **Sala del Maggior Consiglio** (Hall of the Greater Council). Its size is truly incredible: measuring 54 meters long, 25 meters wide and 15.2 meters high (177 feet, 82 feet, and 50 feet respectively), it takes up the palace's entire southern wing. Before the great fire of 1577 the hall was filled with remarkable paintings by Pisanello, Gentile da Fabriano, the Bellinis, Carpaccio, Titian, Veronese, and Tintoret-

Bust of the Doge Venier, by *A. Vittoria*; below: *Room of Henry IV*.

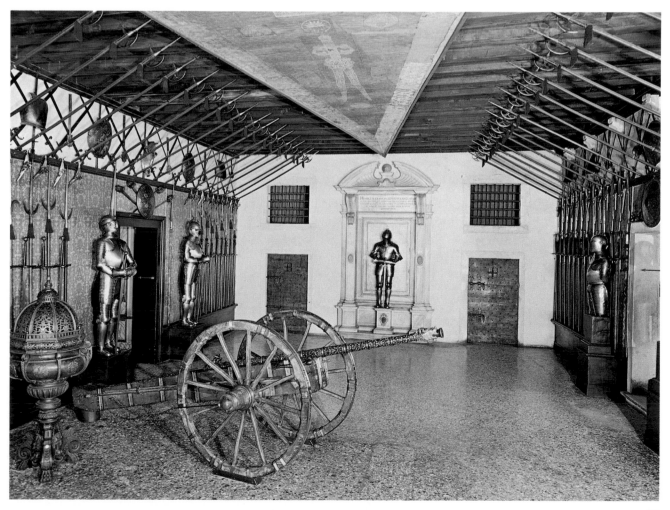

Opposite: *Sala della Quarantia Civil Vecchia*; below: *Sala del Maggior Consiglio.*

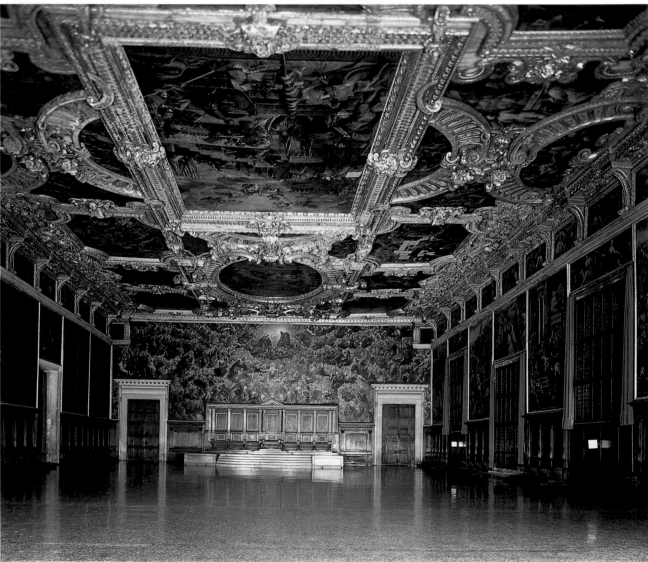

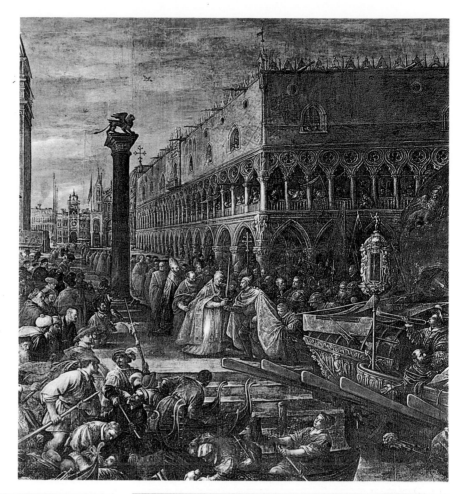

to, all of which were unfortunately destroyed. The hall itself was immediately restored by Antonio Da Ponte and at the same time a new decorative scheme was drawn up. The end wall is wholly covered by the world's biggest oil painting (72×22 feet), painted by the great Jacopo Tintoretto and his son Domenico around 1590 to replace Guariento's earlier version of the same subject, *Paradise*. The other wall paintings are by Palma the Younger, Leandro Bassano, the Tintorettos, and others. The ceiling contains a remarkable oval painting by Veronese, the *Triumph of Venice*, which is striking for its spectacular scenic effects. We then enter the **Sala della Quarantia**

Civil Nova. This council was set up to assist the Quarantia Civil Vecchia in carrying out its tasks. Finally we arrive at the **Sala dello Scrutinio** in which the ballots cast by the members of the Greater Council during elections were scrutinized. This room too was destroyed in the 1577 fire. The ceiling contains paintings by Francesco Bassano, Andrea Vicentino, and others, while paintings by Tintoretto, Palma the younger, and others adorn the walls. The *Triumphal Arch* on the end wall was built in 1694 in honour of Francesco Morosini, after a design by Gaspari and decorated by Lazzarini.

Returning once more to the Scala dei Censori we now

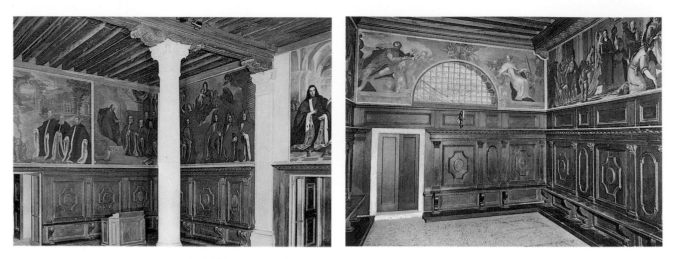

Sala dell'Avogaria or *dei Notari* and the *Sala della Milizia da Mar*.

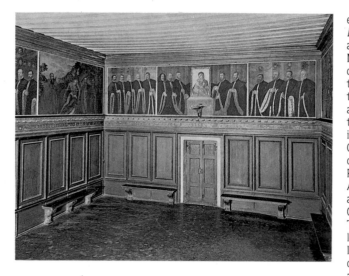

Sala dei Censori; below: *Sala dello Scrigno*.

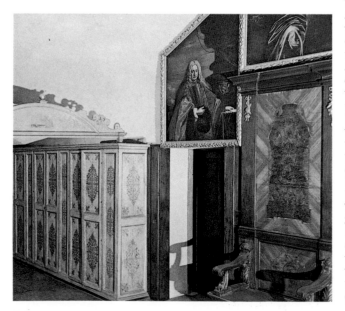

enter the **Sala della Quarantia Criminal** which has a fine *Lion of St. Mark* by Jacobello da Fiore dated 1415. In the adjoining **Sala del Magistrato alle leggi** and **Sala del Magistrato al Criminal** are the *statues of Adam and Eve*, carved by Antonio Rizzo in 1470 for the Foscari Arcade in the court downstairs. Next is a small room adorned with two half-moon lunettes of a *Virgin and Child* by Titian and a *Saviour* by Giuseppe Salviati, both originally painted for the Sala del Senato. This room leads to a passageway inside the famous Bridge of Sighs, which spans the Palace Canal and comes out at the **Prigioni Nuove** (New Prison), designed by Da Ponte when the Prigioni Vecchie (Old Prison) located in the Doges' Palace became overcrowded. Actually, the Bridge of Sighs has two passageways, one above the other. One of them leads from the Quarantia Criminal, as we have mentioned, to the Prigioni Nuove. The other one goes to the floor of the Doges' Palace loggias where the **offices of the Avogaria** were situated. Inside the Prigioni Vecchie were the Piombi (previously discussed) located just below the lead roof of the palace and the **Pozzi** (literally, wells). Nevertheless, even the deepest dungeons where the most dangerous criminals were kept were still above the water level of the canal. The cells of the pozzi leave the visitor with a sense of anguish and bleak horror; it is not very hard to imagine the thoughts of those once locked up there. The **Sala dei Censori** served as headquarters for the two magistrates whose job it was to investigate the mores of the nobles and to make sure that elections and distribution of public offices were properly handled. Along the walls runs a frieze with the coats-of-arms of the *266 Censors*. Their portraits were painted by Domenico Tintoretto, Antonio Palma, and Paolo dei Freschi. The *Virgin and Child* above the doorway is by a follower of Vivarini. From this room we reach the **Sala dei Notai**, or **Sala dell'Avogaria**. The walls are hung with portraits of famous Notai and Avogadori (magistrates) and several religious scenes by Leandro Bassano and Tintoretto's school. On one of the walls hangs an odd clock with only six hours shown on the dial. The Avogaria was in charge of the so-called Gold and Silver Books kept in the adjoining Sala dei Notai which listed the noble families of the city. Next comes the **Sala dei Provveditori della Milizia da Mar**, once headquarters for the captains of the militia in charge of recruiting men for the fleet of the Serenissima. The walls are decorated with 18th century frescoes in Tiepolo's style, one of which (the *Adoration of the Magi*) has been attributed to Gian

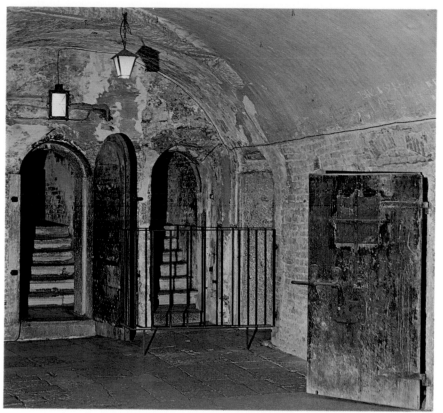

The «piombi» prison cells and the torture chambers; right, top: entrance to the new prisons; below: inside a cell in the «pozzi».

Domenico Tiepolo. A small room once served as the office of the segretario alle Voci (secretary of the Items) who was in charge of recording the attribution of public offices. On a wall is the *Lion of St. Mark between Sts. Jerome and Augustine* by Donato Veneziano dated 1459.

The **Room of the Bolla Ducale** (Doges' Seal) was the office of the man in charge of stamping the doges' official papers who was called the «Bolador». Lastly, the **Doges' Chancellery**, where the Collegio dei Notai met, may be visited upon request.

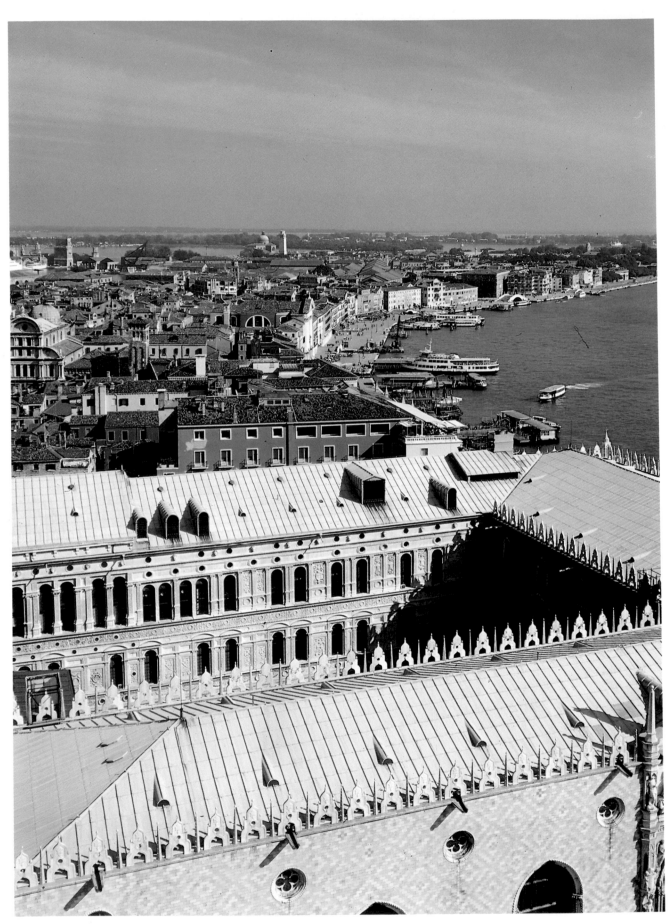

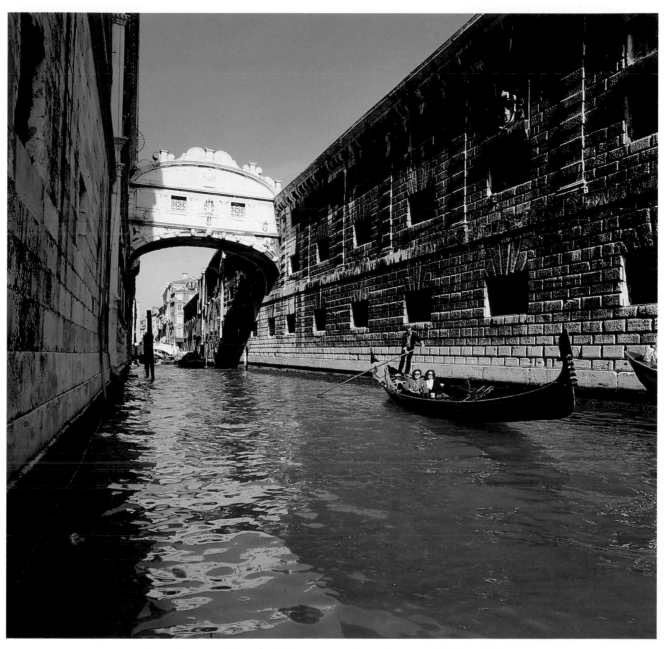

Preceding page: *Riva degli Schiavoni seen from above*; top: *Bridge of Sighs*.

THE BRIDGE OF SIGHS
PONTE DELLA PAGLIA – RIVA DEGLI SCHIAVONI

As soon as our tour of the Doges' Palace is over, we return to the Piazzetta and, turning left, we walk down to the quay where we can get a glorious view of the docks. To the left, along the southern side of the Palace, we come to the **Ponte della Paglia** (Straw Bridge), perhaps nicknamed for the prisons. It was built in 1360 and then enlarged in the 19th century. The Straw Bridge spans the Palace canal and overlooks one of the most photographed sights in Venice, the famous **Bridge of Sighs** with its graceful pink outline standing out against the shadowy recesses of the canal. The bridge joins the Doges' Palace to the 16th century Prigioni Nuove and was designed by Antonio Contini in the decorative 17th century Baroque style. The sighs the bridge was named for actually go back to a 19th century Romantic tradition, they were probably the tragic expressions of the condemned as their last glances at Venice pierced the grille windows along the way. Beyond the Ponte della Paglia we continue down the **Riva degli Schiavoni**. Lined with coffee houses and hotels, the Riva skirts the docks down to the Giardini di Castello, the park where part of the Biennial Art Show is held.

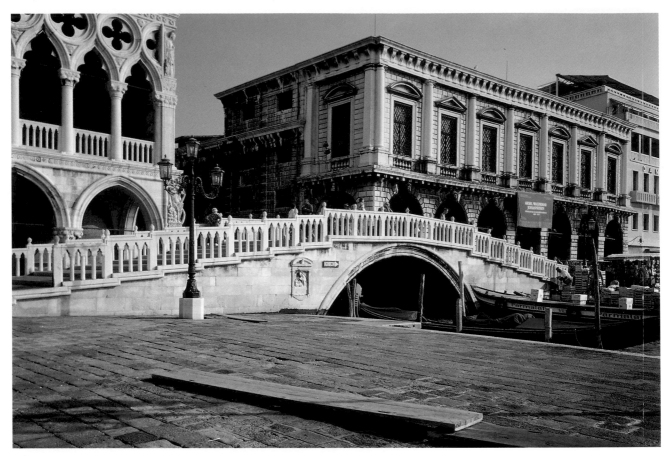

Ponte della Paglia; alongside: *Palazzo delle Prigioni Nuove (the new prisons).*

Opposite: *Piazzetta San Marco seen from the Ponte della Paglia*; below: *Riva degli Schiavoni*.

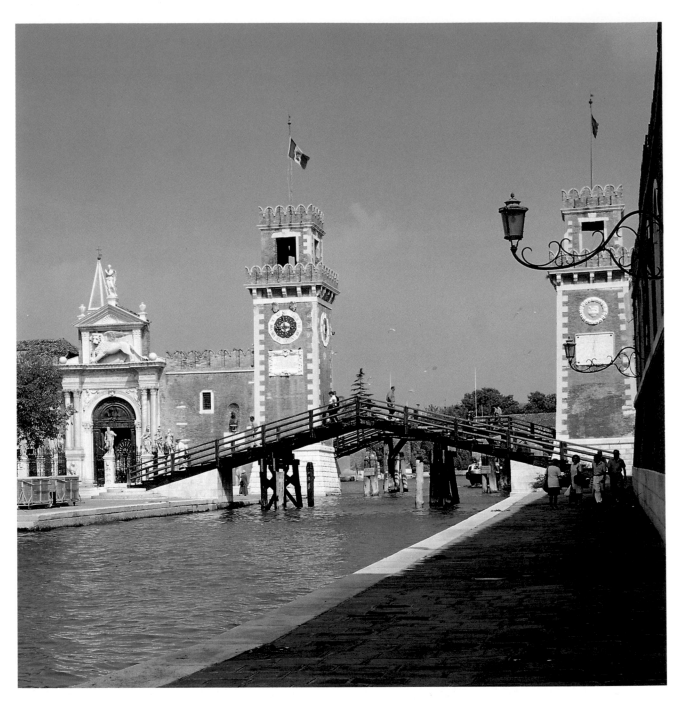

The Arsenale.

THE ARSENALE OR SHIPYARD

Built as a shipyard for the Republic's fleet, the Arsenale underwent alterations and enlargements throughout the centuries. The impressive entrance consists of a gateway flanked by two marble Lions. One of the 16th century buildings that once belonged to the old Arsenale presently houses the **Museo Storico Navale** (the Historical Navy Museum) which contains relics of Venice's glorious seafaring past. One of the outstanding models of seacraft on display is certainly the *Bucintoro*, a faithful reproduction made in the 19th century of the original built in 1728. This craft was traditionally used by the doges for their symbolic Marriage to the Sea ceremonies.

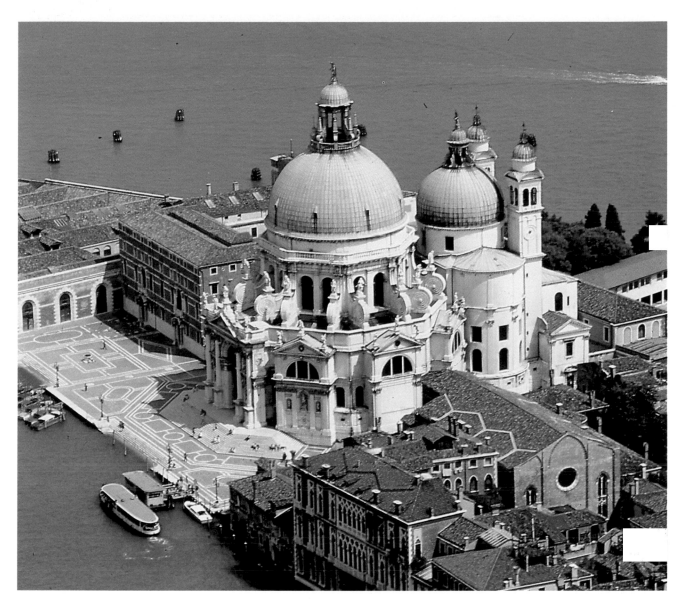

The church of Santa Maria della Salute.

THE CHURCHES

We have already discussed the churches along the Grand Canal; San Simeone Piccolo with its green dome; Santa Maria degli Scalzi; the picturesque San Geremia; the spectacular church of the Salute; the white-fronted church of San Giorgio Maggiore; and last but not least, the Church of San Marco. Nevertheless, it should not be forgotten that Venice, a city whose every activity – be it political or commercial – has always been deeply rooted in relgious spirit, is dotted with countless churches of all sizes, shapes, and periods, for it was in the name of religion that the Venetians conquered lands, started businesses, and fought battles. We shall now take a brief look at some of Venice's most interesting churches. There is no particular order – the churches are described as they would appear to a sightseer wandering about the city enthralled with the joy of discovery.

SANTA MARIA DELLA SALUTE

The vicissitudes throughout the construction of the church were many: indeed here we shall recount the most interesting ones. In 1630 Venice was struck by a terrible plague which caused thousands of deaths. The Senate deliberated that, should Divine Providence intercede on the city's behalf, the citizenry would erect a huge church in honor of the Virgin. The plague ended and the Senate announced a competition for the design of the church. All the outstanding architects of the day took part and the project was awarded to a young man, Baldassarre Longhena. Work began in 1631, but soon grave difficulties set in. First of all, the area was unable to support the weight of the building going up and the ground began to subside. Longhena solved the problem by sinking piles deep into the soil. But his troubles were not yet over. When the central dome was about to be set up, it looked as though

The interior of Santa Maria della Salute; below: *the inside of the dome*.

Opposite page: *the church of Santa Maria della Salute*.

the walls, would be unable to bear its weight. Longhena thought up an ingenious solution: he added the Baroque scrolls. They support the drum of the dome and give the church its unique and distinctive appearance. By the time the church was consecrated in 1687, Baldassare Longhena had been dead for five years. Ever since, on November 21st each year, a picturesque procession, in which the whole city of Venice takes part, is held. On this occasion, a bridge connecting the church to the opposite shore is put up. The church has an octagonal plan and is surmounted by a great dome and a smaller dome directly over the choir.

THE INTERIOR – At the first altars on the right are paintings by Luca Giordano: the *Presentation of Virgin at the Temple*, the *Assumption*, and the *Nativity of the Virgin*. At the third altar on the left is a late work by Titian, the *Pentecost*. The marble sculpture on the main altar represents the *Plague Fleeing before the Virgin* and is by Giusto Le Court. The large sacristy contains a wealth of unforgettable Titian masterpieces: the *Death of Abel*, the *Sacrifice of Abraham*, and *David and Goliath*, dated 1543 on the ceiling, and over the altar, a youthful work of 1512, *St. Mark and Other Saints*. The works of other artists adorn the walls. Outstanding among these is one of Tintoretto's most famous paintings, the *Wedding at Cana*.

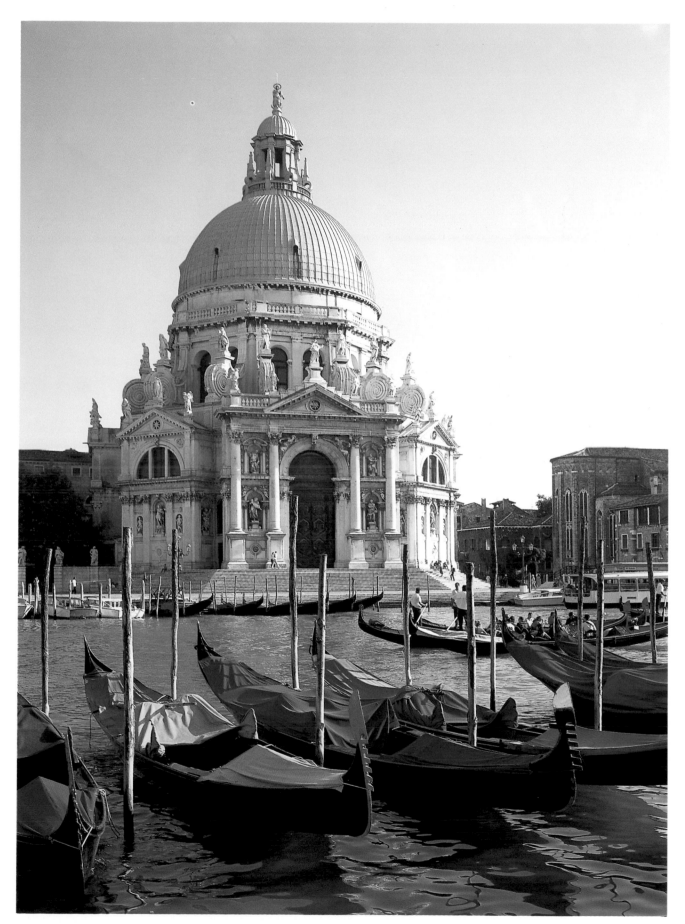

The church of Santa Maria Formosa; alongside: *The Nativity of the Virgin,* by *Bartolomeo Vivarini.*

SANTA MARIA FORMOSA

The Church of Santa Formosa dominates the square of the same name in the Castello district. The church dates back to the 7th century A.D. when the Virgin appeared to the people in a vision as a plump («formosa») matron. In 1492 it was rebuilt by Mauro Coducci with a double façade (one facing the square and one overlooking the canal). The belltower is a later (17th century) Baroque addition. Inside, the first chapel to the right contains a remarkable triptych by the 15th century Venetian master, Bartolomeo Vivarini.

The church of San Zanipolo; bottom: *equestrian monument to Bartolomeo Colleoni* by *Andrea Verrocchio*.

SAN ZANIPOLO

Zanipolo is simply the contraction in Venetian dialect of Giovanni (John) and Paolo (Paul), the names of the saints to whom the great church is dedicated. San Zanipolo rises upon the campo of the same name, not far from Santa Maria Formosa in the Castello district. Dominating the spacious square is the famous bronze **equestrian monument to Bartolomeo Colleoni**, condottiere (captain) of Venice. Begun by Verrocchio in 1481, it was cast in the 1490s by Alessandro Leopardi, who is also responsible for its pedestal. Inside are the mortal remains of the Republic's best known figures. Begun by the Dominicans in 1246, it was not finished until 1430. The lower section of the façade is adorned with Byzantine reliefs which perfectly complement the elaborate marble Gothic style portal designed by Bartolomeo Bon (mid 15th century). The interior is in the form of a Latin cross with ten pairs of huge pillars separating the lofty aisles from the nave. Around the doorway are three *tombs of members of the Mocenigo family*, the finest of which was built for Doge Pietro Mocenigo by Pietro Lombardo (1485). Starting our visit from the right side, we note a *Virgin and Saints* by Francesco Bissolo on the first aisle, followed by a 16th

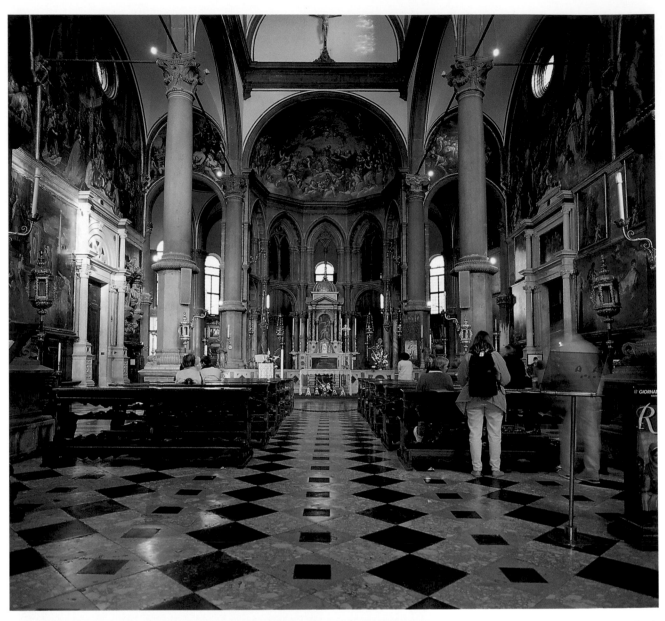

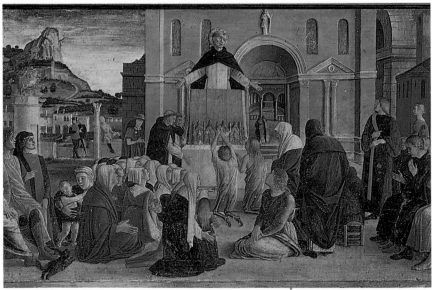

The interior of the church of San Zanipolo; opposite: *Sermon of St. Vincent*, from the polyptych attributed to *G. Bellini*.

century *monument to Marcantonio Bragadin*, military hero, attributed to Vincenzo Scamozzi, and an altarpiece by Giovanni Bellini depicting *San Vincenzo Ferreri*. Next comes the *addolorata* Chapel, built in the 15th century, but which is now completely covered with elaborate Baroque decorative motifs. On the ceiling of the last chapel along the right aisle, dedicated to St. Dominic, there is a fine fresco by Piazzetta, (1727), depicting *St. Dominic in Glory*. The right transept has a *Christ Carrying the Cross* by Alvise Vivarini. The chapels of the apse are lined with several fine funerary monuments of famous Venetians. From the left transept we reach the *Chapel of the Rosary* commissioned by the Confraternita del Rosario in Thanksgiving for the Christian victory against the Turks at Lepanto in 1571. Unfortunately, it was totally destroyed when a fire broke out in 1867 and works by Tintoretto, Palma the Younger, Bassano, Titian, and Bellini were burnt to ashes. A restoration project begun in 1913 has salvaged a part of the original decoration, which may now be viewed. The ceiling paintings by Veronese

originally came from the Church of Umiltà. The 18th century statuary along the walls and the pair of *bronze candlesticks* are by Alessandro Vittoria. The left aisle has several fine funerary monuments by various masters, among whom Pietro Lombardo. A *statue of St. Jerome* by Alessandro Vittoria decorates the first altar. The façade of the **Scuola Grande di San Marco** faces into the Campo San Zanipolo, while a side overlooks the Rio dei Mendicanti, a charming canal (the Venetian «scuole» were charitable religious congregations, mostly founded around the mid 1200s by the Franciscan and Dominican orders). Established in 1437, it was burnt down in a fire and completely rebuilt by Pietro Lombardo and Mauro Coducci from 1485 to 1495. It now serves as a public hospital. On the second floor is the *Salone del Capitolo* which has a fine 16th century wooden ceiling and an altar by followers of Sansovino. From here we enter the *Sala dell'Abergo* with a gold and blue painted wooden ceiling by Pietro and Biagio da Faenza. On the walls are paintings by Palma the Younger, Mansueti, and Vittorio Belliniano.

Scuola Grande of San Marco.

Opposite: *the church of Santa Maria Gloriosa dei Frari*; below: *the interior.*

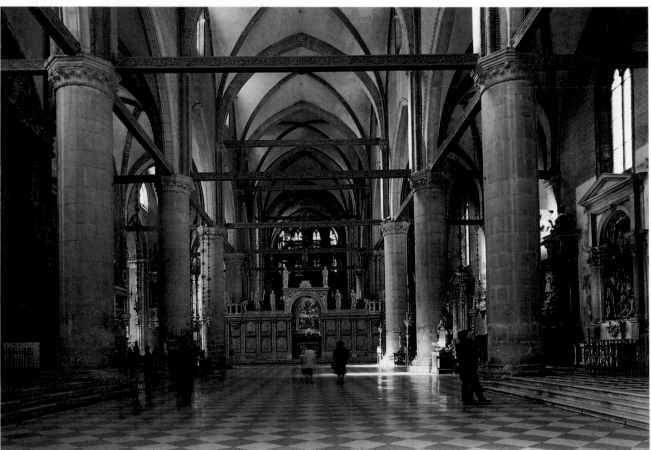

SANTA MARIA GLORIOSA DEI FRARI

Also known as Santa Maria Assunta, the Church of the Frari on the Campo of Santa Maria Gloriosa dei Frari is one of Venice's most important monuments. It contains the tombs of several rich and famous Venetians. Begun by the Franciscan monks around 1520, it was re-elaborated and enlarged by Scipione Bon in 1338 and not finished until 1443. The Latin cross interior is truly majestic in its Franciscan simplicity. Along the walls are various altars, the first of which, on the right aisle was designed by Longhena and adorned with statues by Le Court. In the second bay is a *monument to Titian*, put up in the 19th century above the spot where the master is believed to have been buried in 1576. The third altar contains a fine marble *statue of St. Jerome* by Alessandro Vittoria. In the fourth chapel is an altarpiece by Palma the Younger depicting the *Martyrdom of St. Catherine*. Proceeding to the right transept, we find the monument to the Venetian admiral Jacopo Marcello by Pietro Lombardo (15th century) and the fine funerary urn of Fra Pacifico. On the altar in the sacristy is an outstanding work, a triptych altarpiece by Giovanni Bellini, showing the *Virgin Enthroned with the Child, Angel Musicians, and Saints*. Dated 1488, it still has its original frame. The third apse chapel also contains an interesting work: Donatello's powerful wooden statue of *St. John the Baptist*. Behind the main altar in the choir is Titian's renowned *Assumption* altarpiece, painted in 1518. The remarkable *St. Ambrose* altarpiece by Alvise Vivarini adorns the third apse chapel on the left. The second altar off the left aisle preserves another well-known masterpiece by Titian, the *Madonna di Ca' Pesaro*, painted in 1526.

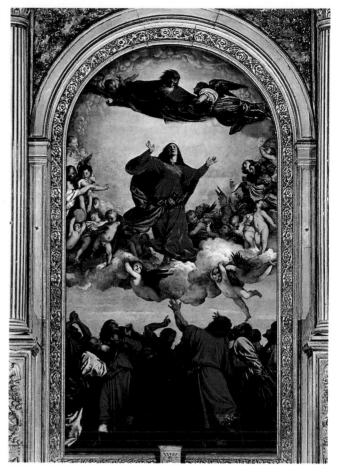

The Assumption by *Titian*; below, from the left: *monument to the Doge Tron*, by *A. Rizzo* and *Madonna Enthroned with Four Saints*, by *G. Bellini*.

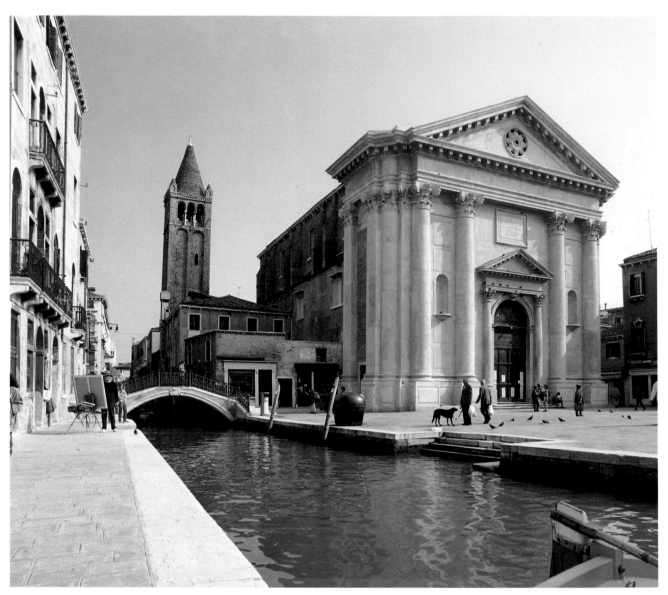

The church of San Barnaba.

SAN BARNABA

Not far from Palazzo Rezzonico in the Dorsoduro district we find the Church of San Barnaba dominating campo San Barnaba. It was built between 1749 and 1776, by Lorenzo Boschetti with a Classical Palladian style façade characterized by stately Corinthian columns surmounted by a triangular tympanum. Alongside is a fine 14th century brick belltower, on top of which is a conical cusp. Inside, Corinthian columns line the aislelless nave. On the ceiling is a fresco representing *St. Barnabas in Glory* by an 18th century follower of Tiepolo, Costantino Cedin. The first altar on the right has a *Nativity of the Virgin* by Folér. But the most interesting works are to be found in the choir: on the main altar, *St. Barnabas with Various Saints* by Damiano Mazza, on the walls the *Ascent to Calvary* and the *Last Supper* by Palma the Younger, and, above the altar, a striking *Holy Family* by Veronese. The Rio di San Barnaba goes from Campo San Barnaba passing Palazzo Rezzonico before flowing into the Grand Canal.

SAN ROCCO

The church contains the body of this French saint who spent his life looking after the sick. The church was begun in 1489 and finished in the eighteenth century. The façade, which was inspired by the work of Coducci in the nearby School of San Rocco, is by the architect B. Maccaruzzi who built it between 1765 and 1771. In the lunette of the doorway a bronze reproduction of a pre-existent marble relief *San Rocco Borne to Heaven by Angels*, by G. Marchiori. The statues of *San Pietro Orseolo* and *San Gherando Safredo* are by the same artist. In the upper section of the façade, the central panel depicts *San Rocco Assisting the Sick*, and at the sides the statues of San *Lorenzo Giustiniani* and the *Blessed Gregorio Barbarigo*. Crowning the façade *San Rocco between St. Pietro Acotanto and Jacopo Salomonio*, all by G. M. Morlaiter.

Opposite: *The church of San Rocco*;
below: *the interior*.

The church of San Moisè.

interior, of impressive size, has no aisles. On the ceiling is a fresco attributed to Niccolò Bambini representing the *Vision of Moses*. The first altar on the right has an 18th century marble *Pietà* carved by Antonio Corradini and a painting by a follower of the Carracci school, Giuseppe Diamantini, representing the *Adoration of the Shepherds*. On the right there is also a fine *pulpit* dating from the 18th century carved by Tagliapietra. In the second altar is the *Finding of the Cross* by Pietro Liberi. We then proceed to the sacristy. On the altar is a 17th century bronze altarfront with a *Deposition* by two Genoese artists, Niccolò and Sebastiano Roccatagliata. The main altar is another ornate Baroque creation designed by Tremignon and decorated by Meyring. In the choir are 16th century carved wooden stalls. Two remarkable paintings adorn the lefthand chapel: Palma the Younger's *Last Supper* and a late Tintoretto depicting *Christ Washing the Apostles' Feet*. Long ago the Campo San Moisé was occupied by the scuola degli Orbi. The *Scuole* prospered on generous donations and bequests, especially of art works. The only *scuola* still in existence today is the Scuola di San Rocco in the San Polo district. Briefly, the others of great note were: the Scuola di San Marco on the Campo San Zanipolo; the Scuola di San Giovanni Evangelista on the Campo San Stin, in Renaissance style with a 15th century courtyard by Pietro Lombardo; and the Scuola Grande dei Carmini, a charming 17th century edifice attributed to Longhena (with nine paintings by Tiepolo on the ceiling of the top floor).

Opposite: *the church of San Zaccaria.*

SAN MOISÈ

Following the charming Rio San Moisè in the San Marco district we reach the Campo San Moisè and the church of San Moisè. An 8th century church on the site was rebuilt in the 10th century by a certain Moisè Venier who dedicated it to his own name saint, St. Moisè. Later, in the 14th century, the lovely belltower with its distinctive brick spire was raised alongside it. The Baroque façade was designed in the second half of the 17th century by Alessandro Tremignon, for Vincenzo Fini (whose bust can be seen on the obelisk above the central portal), although another artist, the sculptor Enrico Meyring, was commissioned to actually carry out the decorative scheme. The

SAN ZACCARIA

The Campo San Zaccaria is one of the most delightful squares in Venice, combining lovely architecture and peaceful silence. The church building, although commissioned by Giustiniano Partecipazio in the 9th century, was reconstructed several times. Between 1444 and 1465 it was rebuilt by Antonio Gambello in the Gothic style and soon after Mauro Coducci added the distinctive Renaissance marble façade. Simple but effective, it is harmoniously divided into six horizontal sections (or orders), the highest of which, surmounted by statuary, has an unusual hemispherical shape. The statue above the portal (by Alessandro Vittoria) represents *St. Zachariah*.

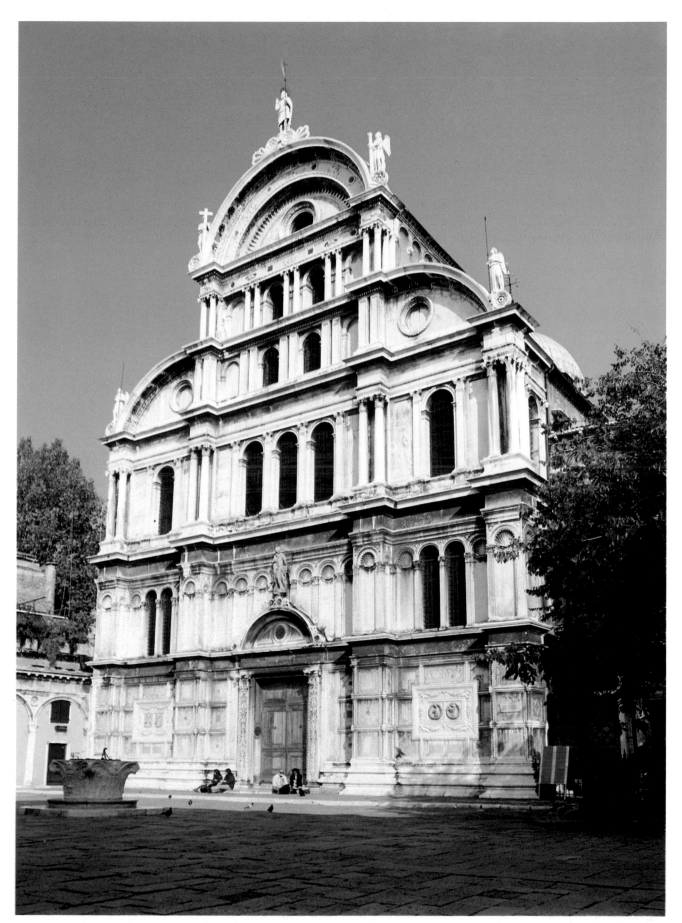

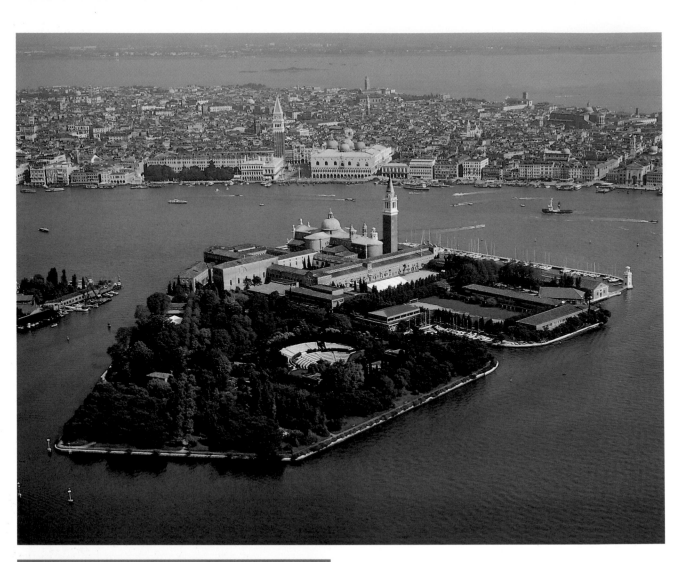

Aerial view of the Island of San Giorgio; below: *the church of San Giorgio Maggiore.*

Facing page: *an impressive view of the sunset over Punto della Dogana seen from the Island of San Giorgio.*

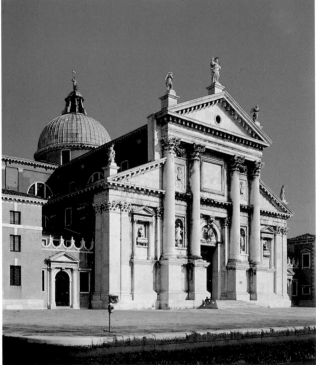

SAN GIORGIO MAGGIORE

The church's stark white façade stands out impressively against the ochre-hued buildings crowding it. One of Palladio's finest designs (the great architect worked on the project between 1565 and 1580), the basilica was finished in 1610 by Scamozzi who, however, followed the master's original plans. The façade once more reveals Palladio's distinctive style: the space is divided into three sections by four columns topped by Corinthian capitals. In the two niches between the columns are statues of *Sts. George* and *Stephen* and, on either side busts of *Doges Tribuno Memmo* and *P. Ziani* by Giulio Moro.

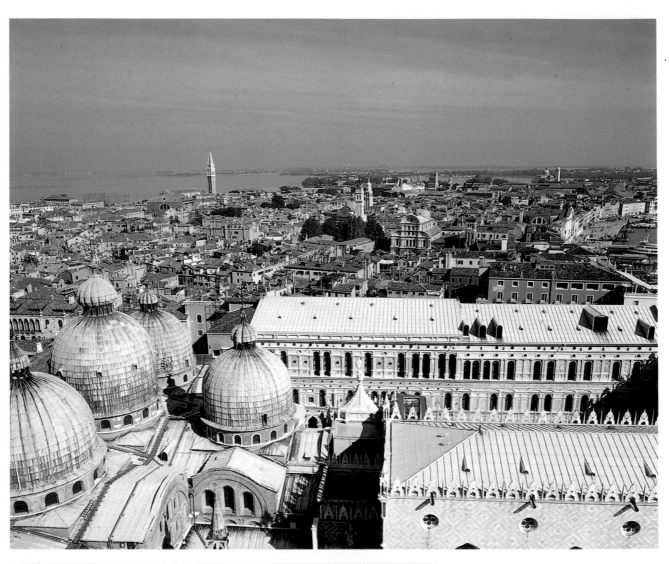

Two panoramas of Venice.

DISCOVERING VENICE

One of the wonderful sides of Venice is the private city, which has nothing to do with the «official» magnificence of its monuments. Take any canal or any corner of the city and all is completely different from anything we are used to in our steel and cement cities. The most striking aspect is the incredible variety – no two canals, streets, or block of houses are the same; every inch of Venice is unique unto itself. It is worthwhile to stop a minute and examine the urban make-up of the city a bit closer. Venice is divided into six sestieri (districts), each of which is criss-crossed by a web of canals. Its tall houses are squeezed incredibly close together on little islets – space has always been at a premium here and this has strongly conditioned urban development throughout the city. Window sills often sport flower pots which add a note of color to the «calli» (streets), «rii terrà» (canals filled in and turned into streets), «campielli» (little open squares), and «salizzade» (paved streets). Typical of Venice, the «sottoporteghi» are tunnels actually cut into the buildings. Life in Venice seems to go on mainly in the streets and squares, especially on summer nights when they serve as public drawing rooms. Nevertheless, Venetians are an extremely active people, with a long tradition in trade and commerce and the crafts. The city is known for its handblown glassware, fine lace, bronze objects, silverware, jewelry, and furniture. Living the life of the Venetians is a truly unique experience: on the following pages is a sequence of views of Venice seen through the eyes of the sightseer intent on capturing its true essence.

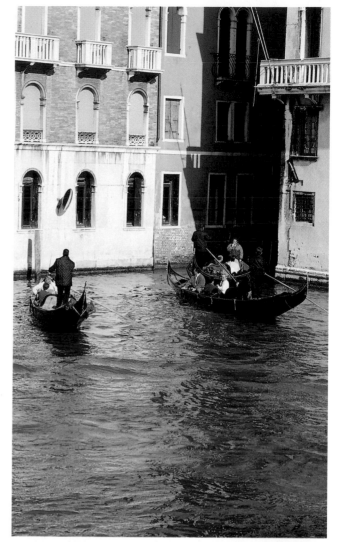

A typical «rio» in the heart of Venice; below: Fondamenta di Santa Maria del Carmine.

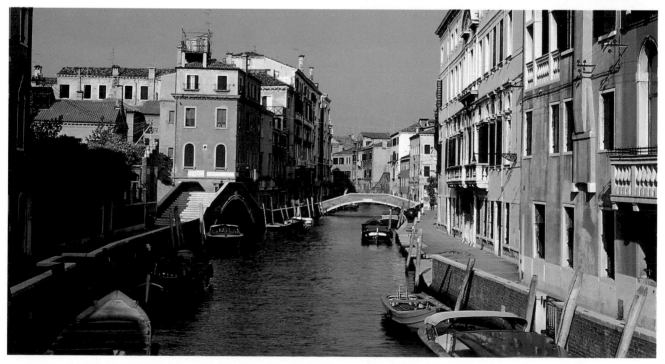

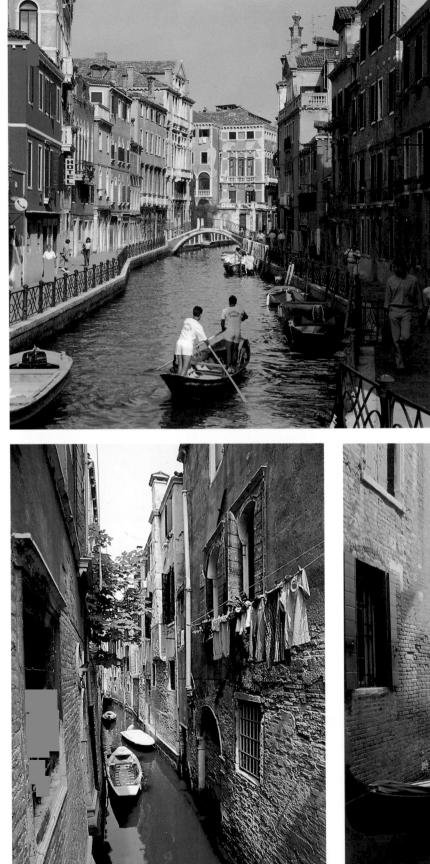

Opposite: *Rio del Cristo*; below, from the left: *Rio del Tentor* and *Rio di Santa Maria Zobenigo*.

Facing page: *a wedding gondola*.

Top, from the left: *a typical Venetian sign* and *well in Campiello Calegheri*; opposite: *the Cannaregio market*.

Facing page: top: *Fondamenta dei Felzi*; bottom: *Fondamenta del Rio Marin*.

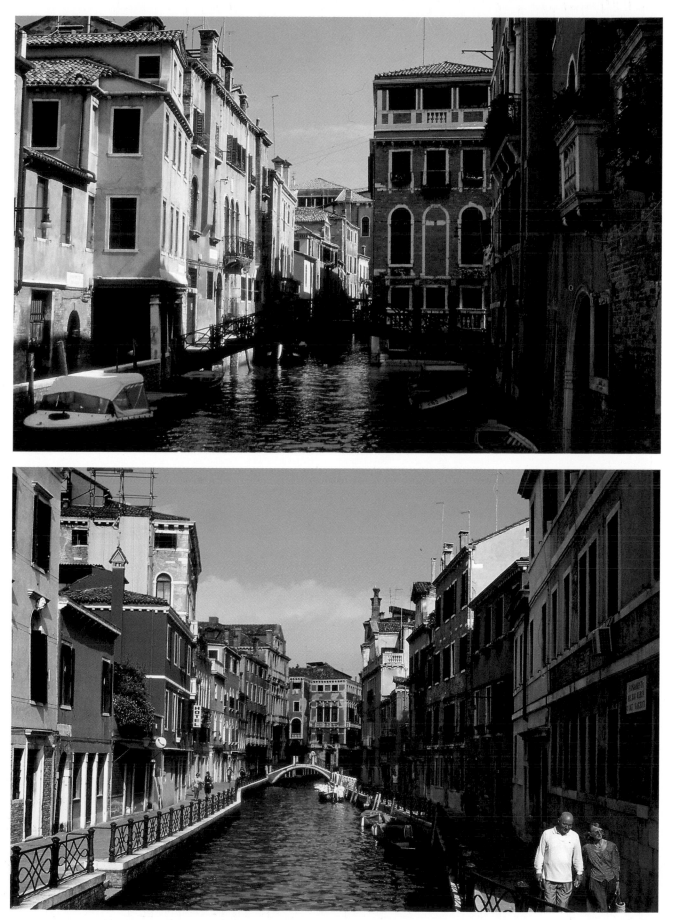

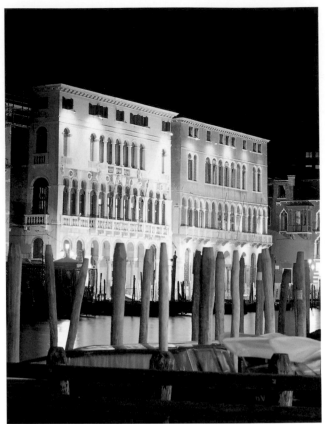

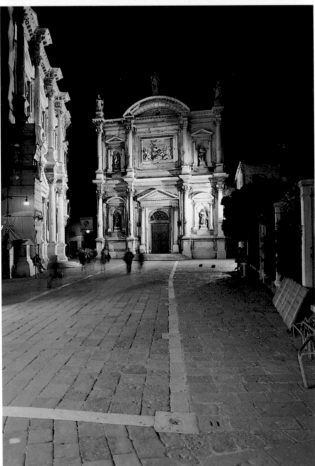

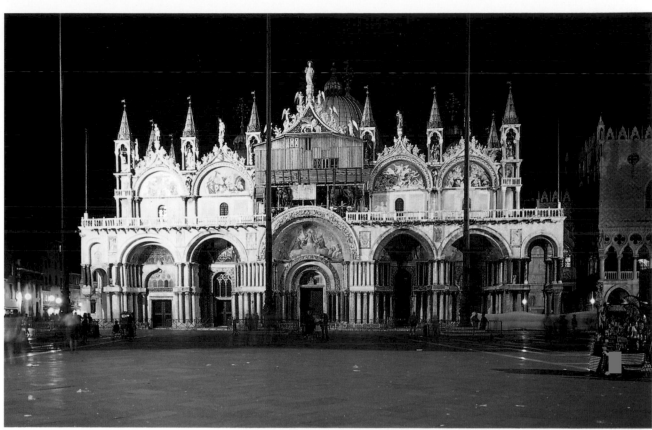

On these two pages: *impressive views of Venice at night*.

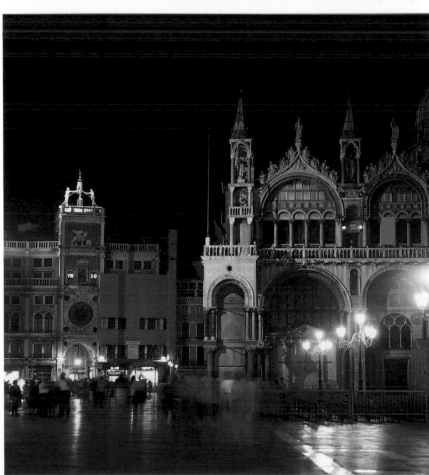

CARNIVAL IN VENICE

The word carnival comes from «carnem levare», i.e.: to put away meat. It has always indicated the festivities between Christmas and Lent. Carnival traditionally commences on St. Anthony Abbot's day (17th January), even though the real festivities take place during the last three days before Lent. Carnival used to be celebrated in truly splendid fashion, in the past, specially in Venice, where the Doge, the aristocracy, the Senate and the ambassadors took part in the popular celebrations of Carnival Thursday, which were marked by the slaying of a bull, by a man suspended from a rope, flying between the belltower of St. Mark's and the Doges' Palace, and fireworks. Over the last few years, the Venice Carnival has regained strength and vigor. Thousands of visitors from every country on the globe flock to Piazza San Marco, the world's most beautiful drawing room, to parade in costumes and masks of every kind, in carefree gaiety.

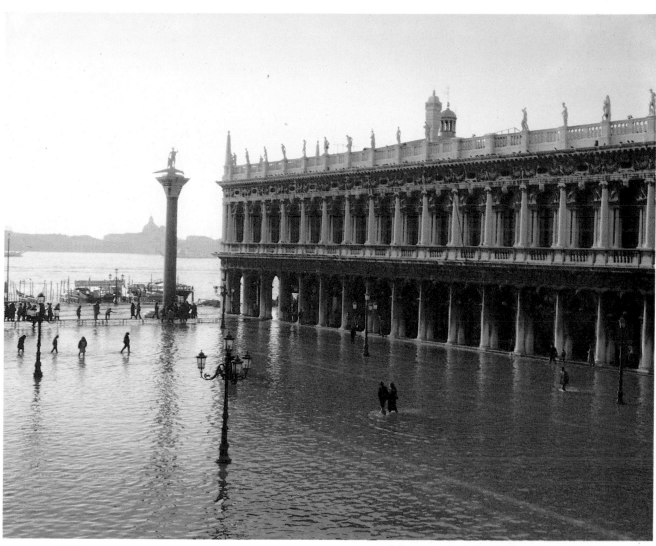

High waters sweep over St. Mark's Square.

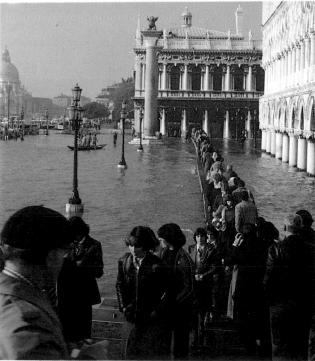

FLOODS IN VENICE

Venice is built upon piles of Istrian pinewood anchored into the lagoon to reinforce the islets on which the buildings rest. The sea, which has always signified the city's economic and political well-being, has often represented danger as well. Sudden tides and sea-storms have time and again threatened the fragile city; nobody will ever forget the terrible flood of November 1966 which at first made it seem as though the city would never survive! The phenomenon of high tides (called «acqua alta» or high waters in Venetian) is common that the Venetians have come to accept them philosophically, without making much fuss. The water seems to have a special fondness for Piazza San Marco and the Basilica, where it can rise to over ½ meters (1 ½ feet) so that gondolas can be seen in the square, or even beneath the arcades.

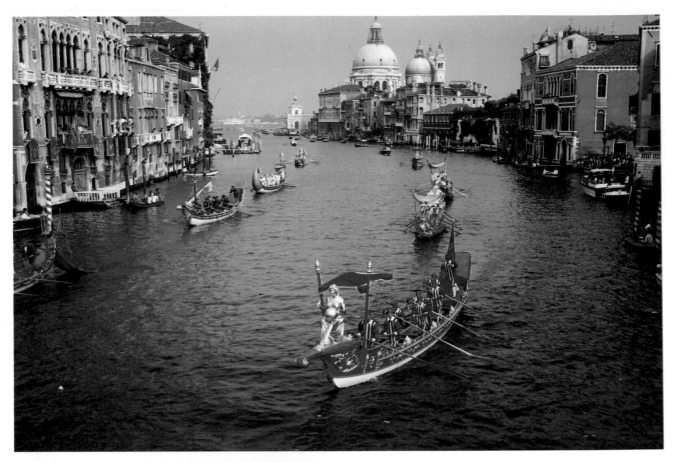

The colorful and historic gondola race along the Grand Canal.

THE HISTORIC REGATA

The custom of holding regatas (gondola races) in Venice, while rooted in the past, is still very much alive today. Of all the regatas, the most spectacular and the most popular is the Regata Storica (historic gondola race) which is held the first Sunday of September. The idea of holding a race of this kind has always been attributed to Doge Giovanni Soranzo, in 1315, though the regata as we see it today dates from a personal initiative of Mayor Filippo Grimani of 1896. A parade proceeds down the Grand Canal, the participants dressed in traditional costume, and is followed by a race contended by the best oarsmen in Venice. The gondolas, laden with ornaments and coats of arms, twice circle the Grand Canal; the local dignitaries and crowds lining the canalbanks can enjoy the colorful pageant before the start of the actual race. In the past, the most important traditional festival was the «Sensa» (Ascension, in Venetian dialect) during which a fair was held in the Piazzetta before the Doges' Palace. At the same time the Doge aboard the so-called «bucentaur» (boat) celebrated the rite known as the «Marriage of the Sea» based on the ceremony performed by Doge Pietro Orseolo II in 999 after a great victory over the Slavs. The ceremony consisted of the doge's throwing a wedding ring into the sea, symbolizing the marriage of Venice to the sea, as he pronounced a vow: «Sea, we hereby wed thee in sign of our genuine and everlasting domination».

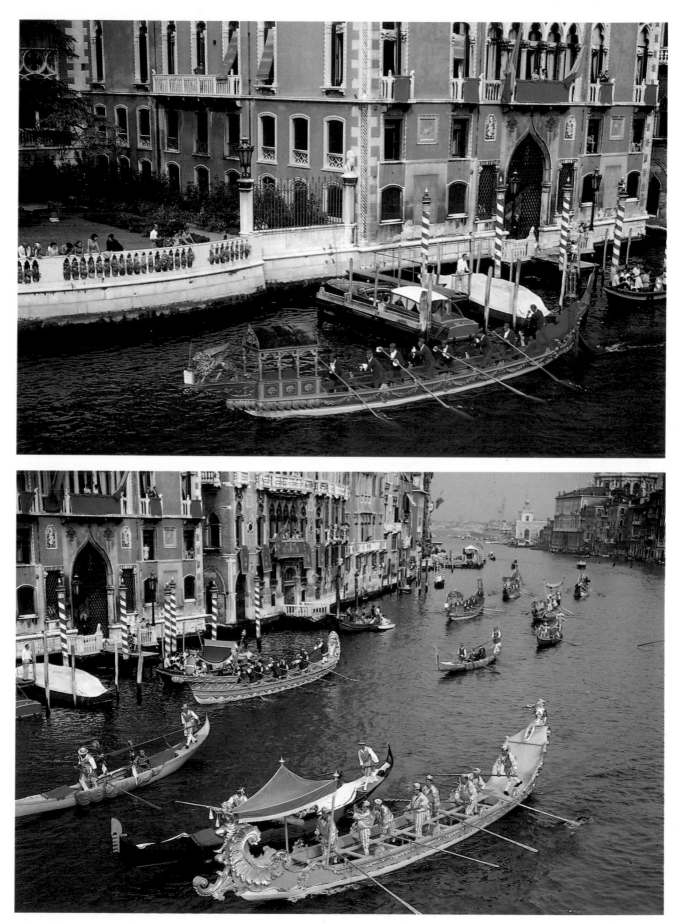

We shall now turn to the group of splendid islands which are like gemstones scattered about the lagoon, the most precious of which is Venice. There are all kinds, ranging in size from tiny uninhabited islets to good-sized islands, now sleepy fishing villages but once thriving cities. A trip to Torcello, Burano, Murano is a must for those who desire to really know Venice. These island cities are fascinating not only for the art treasures they possess, but also for their hauntingly beautiful landscapes in an atmosphere of magical silence.

The Lido of Venice.

THE LIDO OF VENICE

The Lido of Venice is actually an elongated island about a mile from Venice, bordered by a considerable stretch of sandy beach. Once the city's natural defense, it is now a world famous resort. The Lido's fame is based on its well equipped hotels and excellent tourist accomodations.

MURANO

In antiquity Murano was called Amurianum. Just like Burano, its five islets were settled by people from Altinum and other mainland centers who, threatened by the Huns, came in search of safer lands. Murano soon blossomed into a thriving center. Up to the 13th century it was

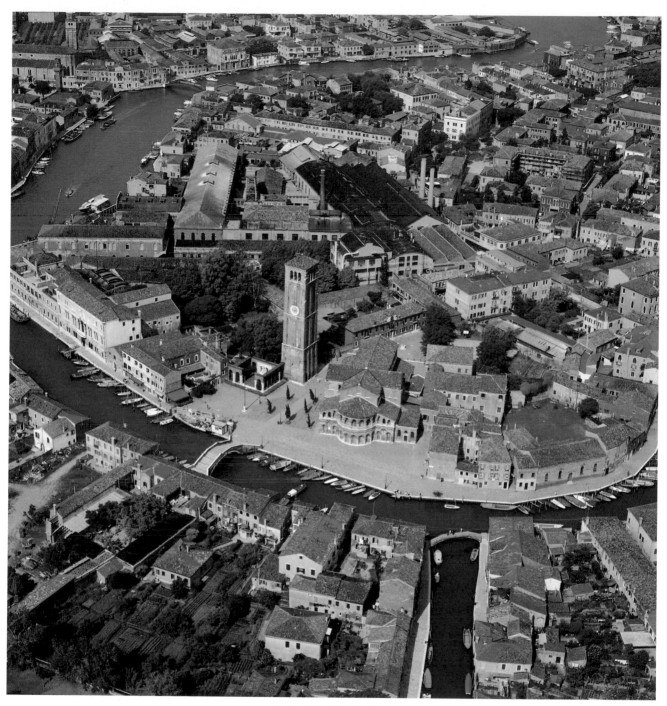

Aerial view of Murano.

completely independent and even after the 1200s, despite being subject to the authority of Venice, it managed to retain its own laws. Murano is known, not only as the native city of the Vivarini, the family of painters who contributed so much to making Venice one of the Italian cities richest in art treasures, but also as the favorite resort for the cream of Venetian nobility. The highpoint came in the 16th century when patrician mansions, villas, and sumptuous palaces went up all along the banks of the island's main waterway, it too called the Grand Canal. Murano also has its share of historical and artistic monu-

ments. Besides the religious buldings, the 14th century **Cathedral of St. Peter Martyr** and the 12th century church and monastery of *Santa Maria degli Angeli*, there are noteworthy secular palaces, especially the 17th century Palazzo Giustinian (today occupied by the **Glass Museum**) and the 15th century **Palazzo da Mula** overlooking the Canalgrande. The latter is the only example extant of the Gothic style, Byzantine-ornamented buildings which once mushroomed along the canal and in the town. However the real jewel of religious architecture in Murano is the **Church of Santa Maria e Donato**. This superb

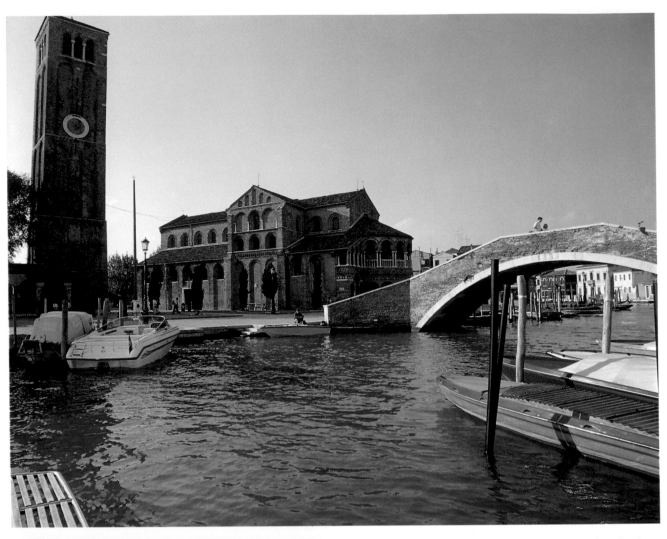

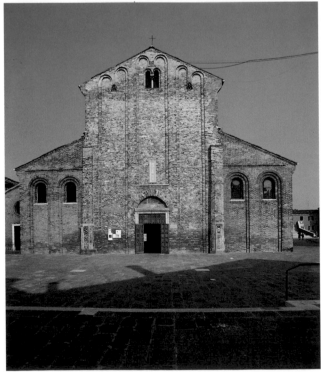

Church of Santa Maria and Donato; below: the façade of the church.

Facing page, top: a typical «rio» in Murano; bottom: some pieces by the master glassblowers of Murano.

example of Ravennate Byzantine decorative motifs used over a Romanesque structure dates from the 12th century, although we know that a church already stood on the spot by the 7th century. The name of San Donato was added to that of the Virgin in 1125 when the mortal remains of the saint were transported here. On the outside, a double row of delicate round arches resting on twin marble columns adorns the apse end – this softens the effect of massive brick solidity. The same powerful effect is given by the Romanesque belltower pierced only by small openings at the top. The cruciform single-aisled interior is decorated with mosaics whose splendor is comparable only to those of St. Mark's – which, incidentally, inspired a number of the motifs in Santa Maria e Donato. Of special note are the *mosaic pavement* and the 13th century mosaic in the semidome of the apse showing the *Virgin* set against a gold ground. One of the earliest paintings of the Venetian school is the *altarpiece of San Donato*. This superb work, painted in 1310 and attributed to Paolo Veneziano, bears portraits of mayor Donato Memmo and his wife.

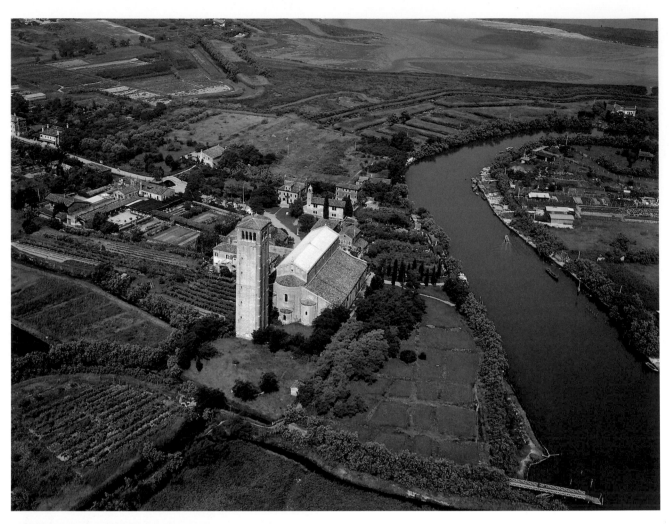

Aerial view of Torcello; below: *the church of Santa Fosca*.

TORCELLO

The origins of this ancient center, whose period of splendor began even before Venice's, are lost in time. Nowadays the visitor arriving at the landing station finds it hard to believe that this tiny village once numbered 30,000 inhabitants and was full of magnificent palaces. It was settled, like the other lagoon islands, by people fleeing the barbarian invaders in the 5th century. There are still remarkable vestiges of Torcello's antique splendor, all of them arranged around the picturesque grass square which is the heart of the village. The piazzetta is dominated by the square-shaped brick belltower built in the 9th century which rises beside the even older **Cathedral of Santa Maria Assunta**. This church is in fact the oldest architectural monument of the lagoon. Despite the fact that it was rebuilt numerous times, it is still one of the most significant examples of Ravennate architecture in the entire region. A simple porch with columns supporting a wooden architrave extends before the plain brick façade. The equally plain interior is extremely beau-

The church of Santa Fosca and the adjacent Cathedral of Santa
Maria Assunta; below: *Attila's throne*.

tiful: marble columns with fine Corinthian capitals divide
the nave from the single aisles. But the highlight of the
church is the series of 12th and 13th century Byzantine
mosaics adorning it. Above the entrance are a superb *Last
Judgment* and the *Virgin in Prayer*, with her air of
dignified majesty. The choir is separated from the nave
and aisles by an iconostasis with remarkable icons dating
from the early 15th century. In the semi-dome of the apse
is a masterpiece of the 13th century Venetian school of
the art of mosaic making. It shows the *Virgin and Child*
like a mystical vision, against a shimmering golden back-
ground. Outside is the so-called «caregon» (chair, in dia-
lect) which according to popular tradition was Attila's
throne, although it is probably just a bishop's seat.
Nearby, just before the façade, are the remains of an
octagonal 9th century baptistery, while behind the
church we find the Chapel of St. Mark in which, according
to legend, the saint's body was laid briefly while it was
being conveyed to Venice. Beside the cathedral is **Santa
Fosca**, a smaller polygonal building; this unusual Raven-
nate construction was built in the early 11th century and
was originally supposed to have had a dome covering. The
Greek cross interior is quite striking.

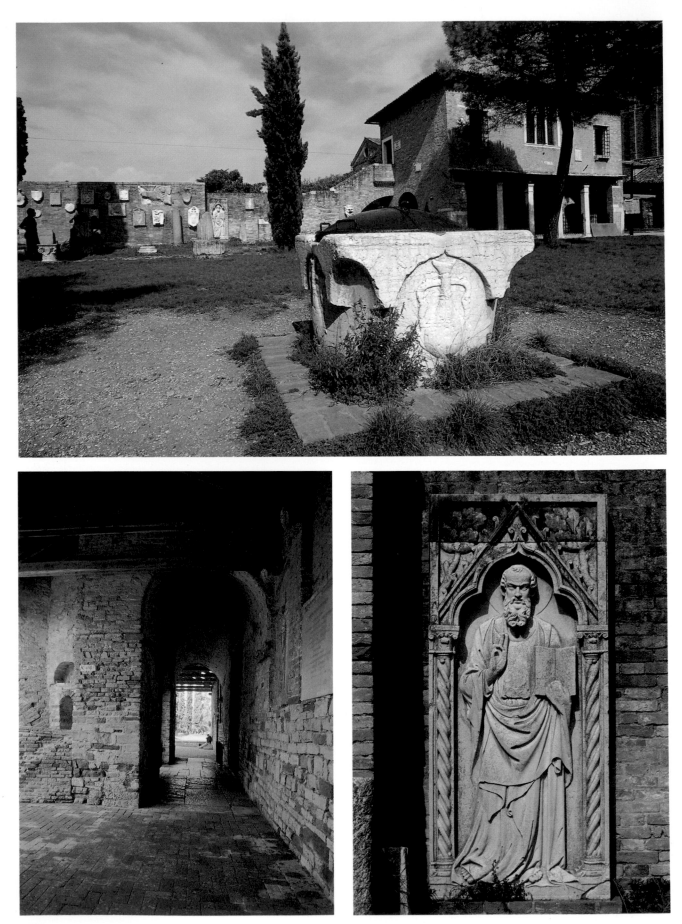

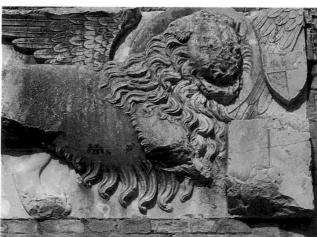

Preceding page, top: *The Palazzo dell'Archivio and the Palazzo del Consiglio* (XIV century); below, from the left: *the portico of the Palazzo dell'Archivio and San Marco, one of the fragments from Altino.*

Above: *Mary Praying, mosaic in the Cathedral of Santa Maria Assunta* (XII cent.); right, from the top: *two details of the Last Judgement in the Cathedral and the Lion of St. Mark, fragment from the Palazzo del Consiglio.*

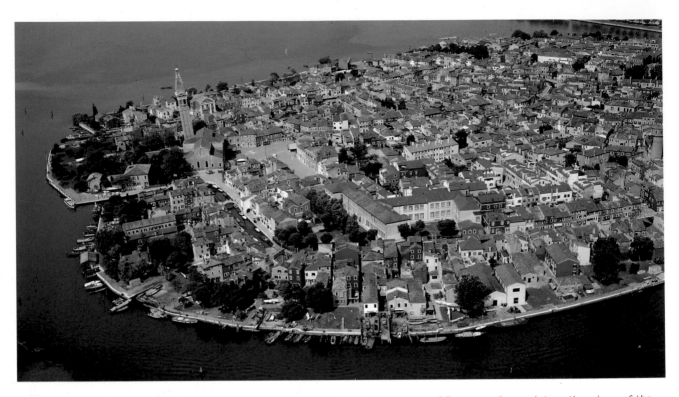

Aerial view of Burano and some interesting views of the island.

BURANO

Burano (originally Burianum or Boreanum) occupies four tiny islands inhabited mainly by fishermen. It was originally settled in the 5th-6th centuries by refugees from Altinum fleeing Attila's Huns. It is famous for the traditional art of lacemaking which the women of Burano have been handing down to their daughters for centuries. The glorious play of colors reflected in the waters of the canals has never ceased to enthrall painters, and still today, you constantly run into them sitting at their easels intent on capturing the geometrical shapes and bright colors of Burano on canvas. But not even an island as tiny as this is without its art treasures. Taking the main road of the village, named after its most famous native son, the 18th century composer Baldassarre Galuppi, known as il Buranello, we soon reach the main square and the 16th century **Church of San Martino**. Alongside it is the belltower which, like the Tower of Pisa, leans dangerously to one side, and the **Oratory of Santa Barbara** which contains works of great interest such as Tiepolo's *Crucifixion* (dated c. 1725), *St. Mark and Other Saints*, by Girolamo da Santacroce (16th century), and several canvases by Giovanni Mansueti (late 16th century). On the same square stands the Palazzo del Podestà now occupied by the Scuola dei Merletti, or **Lacemaking School**, which was founded in 1872.

INDEX

Historical Notes Pag. 3
Arsenale . » 90
Belltower of St. Mark » 38
Belltower's Loggetta » 38

BRIDGES
— degli Scalzi » 7
— of Sighs . » 87
— dell'Accademia » 33
— della Paglia » 87
— di Rialto » 14

CA'
— da Mosto » 12
— d'Oro . » 12
— Foscari . » 19
— Granda (Palazzo Corner) » 33
— Pesaro . » 10
— Rezzonico » 19

Cannaregio Canal » 8
Carnival in Venice » 114

CHURCHES
— San Barnaba » 100
— San Geremia » 7
— San Giorgio Maggiore » 104
— St. Mark's Basilica » 44
— San Moisè » 102
— San Rocco » 100
— San Simeone Piccolo » 7
— San Zaccaria » 102
— San Zanipolo » 95
— Santa Maria della Salute » 91
— Santa Maria di Nazareth » 7
— Santa Maria Formosa » 94
— Santa Maria Gloriosa dei Frari » 99

Clocktower » 40
Discovering Venice » 107
Fabbriche Nuove di Rialto » 12
Fabbriche Vecchie di Rialto » 12
Floods in Venice » 115
Fondaco dei Tedeschi » 12
Fondaco dei Turchi » 8

GALLERIES
— Academy » 22
— Franchetti » 12
— International of Modern Art » 10

Grand Canal » 6
Historic Boat Race » 116
Library of St. Mark » 36

MUSEUMS
— Correr . » 42
— of 18th Century Venice » 21
— of St. Mark » 45
— Storico Navale » 90
Napoleonic Wing » 42

PALACES
— Balbi . pag. 19
— Bernardo » 18
— Boldù . » 10
— Cavalli-Franchetti » 33
— Contarini-Pisani » 10
— Corner della Regina » 10
— Corner (Ca' Granda) » 33
— Dario . » 35
— da Lezze » 8
— dei Camerlenghi » 12
— Ducale . » 63
— Farsetti » 18
— Grassi . » 19
— Gussoni-Grimani-della Vida » 8
— Labia . » 7
— Loredan » 18
— Michiel dalle Colonne » 12
— Papadopoli » 18
— Pisani . » 19
— Rezzonico » 19
— Ruoda . » 8
— Vendramin-Calergi » 8

Pescheria (Fish Market) » 12
Piazza San Marco (St. Mark's Square) » 45
Piazzetta of St. Mark » 37
Procuratie Nuove » 42
Procuratie Vecchie » 42
Riva degli Schiavoni » 87
Scuola Grande di San Marco » 97
Santa Lucia Railway Station » 6
Tetrarchs . » 62

ENVIRONS OF VENICE » 118
Burano . » 126
Lido of Venice » 118
Murano . » 118
Torcello . » 122